Making my Mark

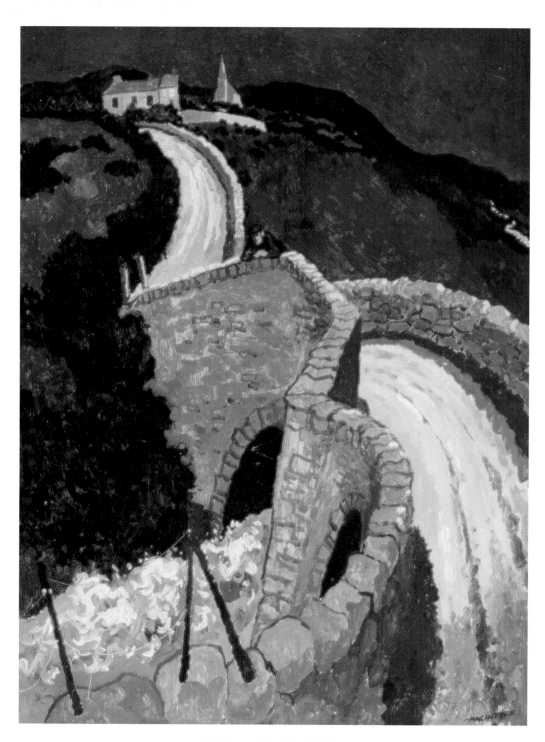

Bridge at Glencolumbkille
1950

Making my Mark

an artist's early life

James MacIntyre

THE
BLACKSTAFF
PRESS
BELFAST

First published in 2001 by
The Blackstaff Press Limited
Wildflower Way, Apollo Road, Belfast BT12 6TA

with the assistance of
The Arts Council of Northern Ireland

Typeset by Techniset Typesetters, Newton-le-Willows, Merseyside

Printed in Ireland by ColourBooks Limited

A CIP catalogue record for this book
is available from the British Library

ISBN 0-85640-707-0

www.blackstaffpress.com

For Amy Elizabeth
a little piece of the past
for a little piece of the future

FOREWORD

The Shankill Road is one of the oldest thoroughfares in Belfast. The name Shankill means 'white' or 'old church' and the original ecclesiastical settlement dates back to the sixth century. In 1911 a font, thought to date to this era, was discovered in the area and now stands at the entrance to St Matthew's Church at Woodvale.

I was three years old when my parents left Coleraine to live at Brookmount Street on the Upper Shankill where I grew up among the hustle and bustle of a long row of terraced houses. In the days before the Second World War brought work to the shipyard and aircraft factory, unemployment was endemic in Belfast and the families of most of my young friends existed on a very low income. In this respect I was more fortunate as my father was in regular work. Brookmount Street, in those days almost empy of traffic except for the occasional horse and cart, was our playground and our Saturday afternoon forays to the local cinema added a bit of spice to our lives.

I drew compulsively from an early age and when I was six, the acquisition of a box of good watercolour paints at Christmas added a new dimension to my life. In the absence of any serious art education I had to learn by trial and error but it was something that came naturally to me and I just kept at it.

Greenisland in County Antrim is seven miles east of Belfast, on the shores of Belfast Lough, and it was here that my grandparents had settled when they moved from Coleraine. The huge basalt escarpment of Knockagh Mountain, with its undulating foothills covered in hazel bushes and little farmsteads, became the inspiration for many of my early drawings.

I left school at fourteen and after a time working as a messenger boy my parents, who thought they were giving me the opportunity of a secure job, had me apprenticed as a motor mechanic where, in fact, I turned out to be the squarest of pegs in the roundest of holes. At the back of my mind had always been the desire to become a professional artist and after nearly five years of mishaps and one near-fatal accident, I eventually, after much agonising, abandoned my apprenticeship to take up art full-time. To my surprise my parents accepted my decision quite philosophically. They had probably given me up as a hopeless case by this time. In any case I embarked on my great enterprise. This book is part of the story of my journey to my goal – a life in art.

JAMES MACINTYRE
2001

The Canary
1948

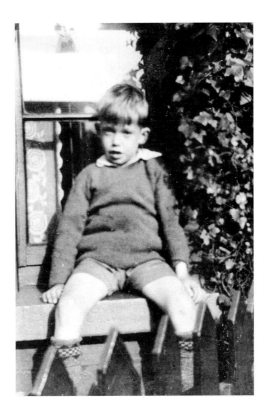

Cecil Hooks didn't stand tall. Innocent blue eyes, magnified by thick lenses on spindly steel wire frames, peered short-sightedly at the world. His flaxen mop was scissored crudely into a bowl-shape and sprouted an obstinate tuft of hair on the crown. Even plastered with rain it still stood proud. He lived in the last house on our long street and on wet, cold and miserable winter days, none of us envied him his extra trek home from school. Nicknamed Hookey, Cecil's myopic vision did nothing to dampen his passion for life. Most of the gang considered him to be a bit mad. This was a view shared by his ma. It was her often voiced opinion that he was nuts and she frequently told her neighbours that he took after his da's side of the family.

Collecting small insects was Hookey's obsession. If a thing wriggled, crawled, jumped, stung, fluttered or burrowed a hole and could fit inside a matchbox, Hookey would pursue it with the energy and concentration of a juggler. He was extremely methodical and would record in minute detail every characteristic of his captives in a battered notebook. He wrote in laborious longhand alongside which he would draw a very crude likeness of each insect. After a couple of days of observation the crawlies, so dubbed by the wee girls, were released back to where Hookey had found them. His most spectacular crawly was a huge, black, hairy caterpillar, the sight of which on one occasion, scattered half the girls in our class and sent them screaming for their mas.

Everyday Hookey would bang on our door asking for me. I think he thought that I shared his passion for crawlies but it was Cecil's drawings that fascinated me. So terrible were they that understanding how anyone could even claim ownership of them was beyond my imagination. Everything was out of proportion – legs too long, heads too big, bodies too short – and I would spend hours correcting, rubbing out and redrawing them. It was useless for me to complain. Hookey would just scratch his head and nod in agreement and we would end by spreading the drawings out on our kitchen table, where pencils of varying degrees of blackness lay scattered, ready for another assault on his hen-like scratches.

One day Hookey dug deep into his trouser pocket and produced a matchbox covered with a little sheet of celluloid, held tightly in place with an elastic band. An orange-coloured centipede sprouting more legs than a hair comb tore around the box in a frenzy.

'How am I supposed to draw that?' I demanded, clenching my teeth.

Hookey rolled his eyes as I worked away, eyeing the specimen's antics as I slowly pencilled a new image on the page. It occurred to me that the drawing might look better in colour and, rashly, I said so. Instantly I knew that I was trapped as securely as Hookey's centipede. He was enchanted by the idea and jigged around in delight, prattling on about what colours would be best.

'What are you two playing at now?'

As if from nowhere the sound of my ma's voice nearly made us jump out of our skins. She eyed the matchbox suspiciously and demanded to know what was inside. I explained that they were Hookey's crawlies and that I was helping him to draw them. I waited for her reaction. I got skewered.

'I've told you not to call him Hookey. His name's Cecil,' she humphed.

Gingerly ma held the matchbox at arm's length, as if fearing that it might explode, and then peered closer. I cringed, primed for instant flight, expecting shrieks of horror followed by an onslaught of verbal abuse and summary banishment from the kitchen. At that moment, high over the kitchen range, the carved wooden clock on the mantelpiece geared up its mechanical rhythms and boomed out five slow chimes. The echoes faded and died away, and in the ensuing silence ma examined the centipede merely remarking that she had seen plenty of them in her time. There was a barely audible sigh of relief from Hookey.

My ma, born and bred a countrywoman, squeamish over a centipede? I should have known better. She calmly scrutinised the squirming insect then turned it upside down and examined its belly. Ma next asked to look at Hookey's book. She carefully read each page and studied the drawings, now and then remarking on the number of times she had swept the various specimens out of her kitchen.

'Cecil, you've made a lovely book. It's a credit to you.' She patted his

shoulder and then took a long hard look at the skimpily-backed volume.

'Jim, give Cecil one of those hardback drawing books I bought. I'll get you another.'

Ma tousled Cecil's mop and disappeared into the scullery where a banging of pots being hauled out from beneath the sink intimated that teatime loomed.

I looked at Hookey. A smile a yard wide split his face as he slowly turned the virgin sheets, fingering the smooth textured paper. Before he left that day we had agreed to start a new book with coloured drawings.

Everyday after school Hookey and I locked heads planning our book in detail. We called it simply *Insects: Written by Cecil Hooks with drawings by Jim MacIntyre.* I drew a fancy border around the title page. We discarded the notion of searching out all the crawlies again and decided instead to consult the section on insects in my da's encyclopedia. I filled every right-hand page from edge to edge with huge brightly coloured pictures of crawlies and for Hookey's benefit I drew faint pencil lines as a guide for his careful printing on the left hand page. I told him to be careful and not to make any messes or spelling mistakes but, even as I spoke, I knew that Hookey rarely made these kinds of errors. In school his intellectual capabilities were widely acknowledged to be superior to those of anyone else.

'A real wee bright spark,' my ma said of him, adding that she wondered who he took after. Which left me pondering what she meant.

A month of concentrated toil completed our masterpiece and we did little to conceal our enthusiasm for it, showing it at every opportunity to anyone who displayed even a modicum of interest. Hookey's ma blinked in silent astonishment but when it was finished his da, proud as a peacock, whisked it into his workplace the next morning. One of his workmates, who was besotted with fishing, browsed though our book and became excited at the sight of a large orange-headed, cream-coloured grub. Delving deep into his overalls he produced a silver threepenny piece and told Hookey's da to ask Hookey to get him six grubs the same as in the picture, and he would pay him regularly for any more that he found.

Being a bright and canny wee soul, Hookey recognised a lucrative market when it stared him in the eye. I did too and we argued over the grubs. He

wouldn't tell me where he found them. I accused him of being a miserable specky-four-eyed-wee-git, reminding him that it was my watercolour that had led to his present good fortune. This stung Hookey sufficiently for him to relent and admit that he found them under docken roots. However, he made me promise not to tell anyone else. The gang were already shadowing him up the Glencairn Road, envious of the jingling threepenny bits in his pocket.

We took our book into school and the teacher enjoyed it so much that she passed it around the other staff members. One day, however, utter consternation took hold of Hookey and I when we were informed that the headmaster, Isaac Abraham, wanted to see us in his hallowed top floor office. Mr Abraham held the children of Woodvale Primary School in a grip of absolute terror. He would march around with his strange stiff-legged gait, sharp beady eyes missing nothing, all the while brandishing a cane of billiard cue proportions which he would use to poke wayward pupils or, even worse, whack them across the knuckles.

'I wish all my pupils were as hardworking and industrious as you two,' he bellowed at us from his awesome height. 'Keep up the good work and let me see more of this,' and he thrust our book back at us as he spoke.

Dismissed and trembling at the knees, Hookey and I were through the enormous glass panelled door and away clattering down the wooden stairs, not daring to look back, just intent on reaching the sanctuary of our classroom.

Most Saturdays half a dozen of us would take off to the pictures, our imaginations caught by the sight of Buck Jones galloping across the screen, six shooters firing on all cylinders as he was pursued by a horde of fiercely painted Indians screaming for his scalp; or Buck cornered in a rocky ravine, twanging arrows quivering all around, unaware of a venomous, scar-faced Indian stealthily stalking him from behind.

'He's behind you, Buck,' we would yell. 'Buck! Look out! He's behind you!'

Roars of rage and apprehension would fill the flickering cinema and we were driven nearly demented as our hero made a sudden turn just as a wickedly long bladed knife buried itself alongside his ear. At these dramatic moments intense excitement hurled us up there along with Buck. We would yell, scream, jump up and down, point imaginary guns and some would tear up and down the aisle, skelping their backsides and slaughtering imaginary Indians as they went. Then, temporarily drained, we would collapse back onto our seats, silent for a moment, chewing furiously on our penny sweets. It was small wonder that we emerged into the daylight an hour later, exhausted but enthused and primed for another session next week. The picture house was like a second home to us.

One particular Saturday afternoon, as the lights were still peeping in the semi-darkness and the audience, growing ever more restless, was whistling and yelling for the start of the film, five of us, Hookey and I in the middle, sat cramped, impatient and garrulous half way down the aisle of the Shankill

Picture Dome, or Wee Joe's, as we called it. Hookey leant over and yelled in my ear.

'I've got two smashing moths to show you!' He groped in his jacket pocket, pulled out the matchbox and gently slid back the lid. While it was barely ajar the moths jumped, fluttered and zigzagged away beyond Hookey's nose, spiralling upwards into the gloomy recesses above us. Hookey gawked, squinting behind his steel frames as he jumped about and peered all round.

'They've gone! Forget about them!' I shouted over the din around us, not even trying to conceal my grin.

Just then the lights gradually dimmed and Movietone News thundered forth as the curtains swished back. Had the newsreel been predicting the world's doom it wouldn't have mattered. All we understood was that when the news ended Laurel and Hardy would cavort for our delight on the silver screen. The cheering grew deafening as the Laurel and Hardy signature tune spun out. Soon Stan, as usual, found himself in trouble with Ollie. He had been reduced to a blubbering-eyed wreck, with us hanging onto every word, when catastrophe suddenly bolted us upright in our seats. The screen was covered with rapidly fluctuating shadows which wheeled and soared and gyrated as though some terrible flapping monster had been released from the earth's bowels.

Silence briefly engulfed the auditorium, leaving Laurel and Hardy screeching away behind the shadows for a further long minute. Then utter bedlam broke loose and the place was swamped with hoots and yells of protest. Hookey's mouth gaped, slack with disbelief and he turned towards me. Without a word passing between us we knew instantly what had happened. I hissed into his ear.

'Keep your gob shut. Don't say anything or they'll hammer the living daylights out of us.'

The din continued unabated for a further ten minutes while harassed attendants flashed torches and threatened to eject the more obstreperous souls out onto the street. Then slowly the lights came up, Laurel and Hardy faded away and the curtains slid closed to a splutter of uproar as disgruntled attendants herded an indignant mob of children towards the exit.

After being assured by the agitated staff that we would get in free next week, we blinked our way onto the sunlit Shankill Road. I looked back and saw Hookey cowering behind me.

A nosy passer-by, intrigued by all the racket, asked the doorman what was going on. In tones of disgust the doorman told him, 'Two bloody moths were flying around in the projector's beam,' and he had no idea how they were going to catch them. Hookey listened to this exchange and suddenly bolted for home, leaving me doubled up laughing. Hookey was the only person I ever knew who managed to close down a picture house single-handed.

We were eight years old when Hookey and I completed our book and we felt quite proud of our achievement. At times we contemplated another one but it never materialised as both of us lost ourselves in other pursuits. My ma decided that Cecil should be custodian of the book and that settled any squabbles over ownership.

Early one bright spring morning as we were setting off to school, a posse of workmen descended upon our street. A huge Clydesdale horse drew a cart laden with tools, planking and trestles and a large wooden hut perched precariously on the rear. Some of the workmen methodically set about erecting the hut, complete with brazier, while others sealed off a section of the street with the trestles and planking, inside which they shovelled a mountain of sand.

Furious housewives leant on their iron gates watching every move with suspicion. For them workmen in the street meant only one thing – extra muck to be cleared up. They could visualise god knows what being trodden into every floor in their houses.

'Mister, what are you going to do with all this stuff?' yelled one, unable to contain her curiosity any longer.

'Concrete Missus, we're ridding you of these cobblestones. From top to bottom the whole street is going to be as flat as a pancake.'

The foreman yanked a huge gold watch from his waistcoat, flipping open the lid while sunlight danced on its gold chain. 'Right lads,' he instructed, pointing a finger, 'Start hauling those cobblestones up from the far end. Half the morning's gone already.'

When Isaac Abraham shook his handbell, heralding the end of another school day, we would march in an orderly fashion out of the rear entrance of the school and never through the huge front doors; they were reserved solely for important people – like Isaac. That afternoon we walked through the ornamental iron gates as usual, yelling with excitement at being released and split into bunches, each walking homeward in various directions.

When we reached Brookmount Street our group stopped short, mesmerised for a few seconds by a cacophony of clanging, diesel fumes, clouds of dust and the sight of a cluster of workmen busily engaged in ripping up the cobblestones with pickaxes. We galloped down the street, filled with curiosity,

schoolbags flapping over our shoulders as we ran. Intent upon their task, the workmen ignored the questions we fired at them from all sides. We skittered about, dodging beneath planks and trestles, excited by the chaotic destruction all around us. Finally, the large portly foreman lost patience and, with a blast on his whistle and a shaking of fists, he scattered us. I raced home bursting to ask my ma what was happening.

'Well, you won't be playing out there for a bit. They're concreting the street,' she said calmly, not raising her head from the baking board which was stacked with soda farls ready for the oven. 'Do you want a piece and jam?'

Ignoring her question I tore outside, floor mats scattering everywhere on the linoleum-covered hall. One of my mates, Billy Boyd, lived a few doors down from us. His house echoed to my thumps on the iron door knocker as, impatience killing me, I hopped around waiting for him to appear. When he did we went out to the road to get a better view of the havoc.

'Mister, how long will it be before the street is done?' chirped Billy, running alongside a workman trundling a barrow.

'Ask the foreman,' he grunted as he dumped a load of cobblestones.

Billy and I looked sideways at each other.

'You ask him,' said Billy.

'No way!' I answered, remembering the furious blasts of his whistle and flailing fists.

We kicked and shuffled stones about the pavement, eventually seating ourselves on the kerb as two more of our mates appeared.

'When do you think we'll be able to skate up and down the street?' asked one lad hopefully through a mouthful of chewing gum.

'Away over there and ask the foreman,' suggested Billy slyly but nobody budged.

A shuddering cement mixer, its innards groaning and clanging, spewed out a final plume of diesel smoke, signalling a halt to the toil of the men. A mantle of silence descended, so absolute that pigeons which had been roosting on the roof tops all day fluttered in circles back down to the street. Housewives missing the racket appeared in doorways, wiping their hands on their aprons and listening to the banter of the workmen, piece boxes jammed under their armpits, as they prepared for home.

The lamplighter had been and gone long before darkness fell. Inside his hut, the wooden seat barely wide enough for him to stretch out upon, the night-watchman strained to read a newspaper illuminated by a hurricane lamp hanging overhead. On the brazier a blackened billycan was perched precariously on a bed of glowing coke. Tea, strong enough to stand on, bubbled furiously. We warily approached the hut, ready for instant flight if a cantankerous bellow should pierce the evening air.

'Warm yourselves there by the fire but behave yourselves or I'll chase you.'

Billy nervously piped up, 'Mister, will it take long to concrete the street?'

The watchman crammed what remained of the sandwich into his mouth, his Adam's apple shuttling up and down in protest, gave a loud belch and said, 'Come a day or two; about six weeks.'

Dismay flitted over us. Six weeks seemed a lifetime.

Over a week of evenings, friendship grew between us and the watchman. He learnt all our names and we called him 'Sammy', just as his workmates did.

'What's wrong with your leg, Sammy?' one of the boys ventured one evening. Sammy had a limp.

'Nothing much, it's a wooden one,' came the reply. A dull thud echoed as he whacked it.

Sammy had been a soldier in the First World War. At the Battle of the Somme shrapnel had blown holes in his leg and the doctors had sawn it off,

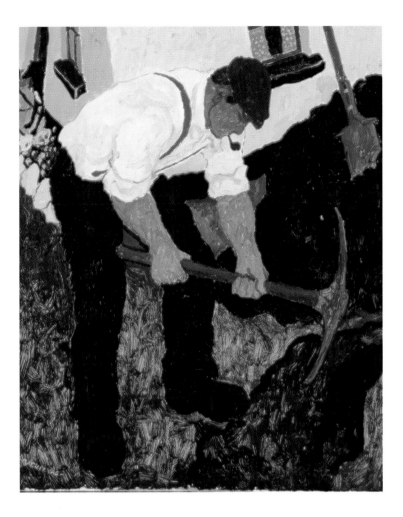

sending him home with a stump. Sitting by his glowing brazier with the hur-
ricane lamp casting shadows all around us, Sammy would weave stories, at
times so funny that shrieks of laughter spilled from us, echoing far beyond the
gloomy shadows surrounding the hut. At other times his harrowing tales of
war, spine-chilling in the telling, prickled every nerve in our bodies and made
the hair on our scalps stand rigid. Some evenings we were even too scared to
venture home alone. On one occasion, as I slipped into the house, my ma
stopped her knitting long enough to give me a searching look.

'Are you alright? You're looking very pale. I hope you're not sickening for
something.'

I said to da who was stuck behind a newspaper, 'Sammy the watchman has
a wooden leg. It happened in the war.'

My da, ever the pragmatist, sucked his pipe and blew a cloud of smoke. 'Well,
at least he came home.'

Sammy's prediction proved pretty accurate. In about six weeks concrete
stretched in a solid sheet from one end of the street to the other. Arriving
home from school one day we found the street deserted and quiet; not a sin-
gle plank of the watchman's hut remained and Sammy too was gone. Long
afterwards we still talked about him and his stories.

Children's street games blossomed in a tremendous surge over the length and breadth of Brookmount Street. Every available daylight hour was spent in pursuit of activities long denied us by the bumpy cobblestones which had hindered and obstructed most ball games. Even football had proved awkward, as did games such as marbles, pirie and whip, cricket, cleek and hoop, carts, or guiders, as we called them. Not any more.

Unfortunately our enthusiasm led to occasional calamities. At times various mothers flew into appalling fits of rage and would rush out onto the street, spitting abuse when their front windows were smashed by a pirie. It would, if we were very unlucky, ricochet off their tiny kitchen walls. Amid howls of protest the culprits would be hauled homewards and the ultimate threat accompanied by a belt around the ears was issued – 'Wait till your da comes home and sees this mess.'

One particular game surpassed all others in popularity. It was exciting, demanded skill and some of us became so proficient at it that we could run rings around the others. Roller skating was all the rage. Even the girls who ordinarily would have stuck their noses in the air at the very mention of playing with us, were belting pell-mell everywhere. Strapped on, mobility gripped our gang from nipper to school leaver. As a consequence, my ma lectured me on the perils of excessive speed and predicted that someone would get their head split open. Thankfully nobody ever did. Occasionally, collisions would upend two or three of us in a heap but there would be nothing more serious to show than a black bump or two the next day.

One cool summer evening, not long after the street had been concreted, a very odd-looking stranger appeared. He was about my age and wore a huge peaked cap much too big for him. Fastened below his chubby chin was a spotted dicky bow. He also sported a belted jacket with large breast and side pockets. It buttoned down the rear and split into a flap which covered his bum. Trousers, or something resembling them, covered the upper half of his legs and at the knee they mushroomed out into a heavily-knitted pair of socks, decorated with a diamond pattern. My ma called them knickerbockers.

This well-fed looking stranger, outlandishly outfitted, displayed not a single blush of embarrassment as he grinned a welcome. 'Hi fellas. I'm Tom Irvine. I'm from the USA.'

To our astonishment, he proceeded to shake our hands, asking names on the way. The wee girls who had suddenly arrived in a giggling bunch began firing questions at him just to hear him talk in his funny accent. By this time half of the street had come out to have a look.

At bedtime, while drinking cocoa and pretending to read a comic, I listened as ma busied herself bending my da's ear by relating the Tom Irvine saga.

'She left the street in a big hurry ten years ago,' ma chuntered. 'This is the first time she's been back.'

I could see that not a single word had penetrated da's concentration. A

boxing match on the wireless and someone being counted out by a clanging bell, riveted him to the armchair. Amid background cheers, a booming voice announced a winner and a wide smile spread across my da's face. Boxing interested him deeply. His being champion police boxer did not impress ma one little bit. She hated the tournaments, especially when he arrived home covered in bruises.

Now he looked at her, 'What did you say?' he asked.

Ma began again.

Apparently, Tom's ma, Molly Johnston, was one of a big family. She had lived down the street from us and had worked as an office assistant in a Belfast shipping firm. One day an American businessman breezed into the office and presented his credentials. Molly's knees had buckled and the resulting whirlwind romance had swept her into his arms while stars, diamond bright, shone in her eyes for all to witness. Amid rumours, conjectures and the unfettered jealousy of her girlfriends, Molly embarked for the States six weeks later, unwed.

Ten years later, knowing that tongues had wagged at her hasty departure, Molly returned to the street with Tom in tow, looking a million dollars. When photographs of the clapperboard homestead were handed around, her old girlfriends, jealous enough when she left, now fumed with unmitigated envy. They enquired whether her husband had any brothers or cousins. Not that it would have made any difference if he had since all of them were now fettered with husbands of their own and lumbered with my mates.

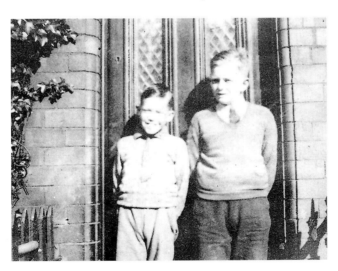

Tom was unprotestingly lugged around the Shankill Road and shown off to aunts, uncles and cousins galore. Rib nudging, giggles and gawkers went unnoticed as splendidly dressed, yankee style, he dandered along the road with Mollie and her ma. But Molly was not so sang-froid about the attention her son's appearance attracted and one day she propelled Tom into an outfitter's shop from which eventually a regular Shankill Road lad emerged. He sported

Tom Irvine (right) and James, 1934

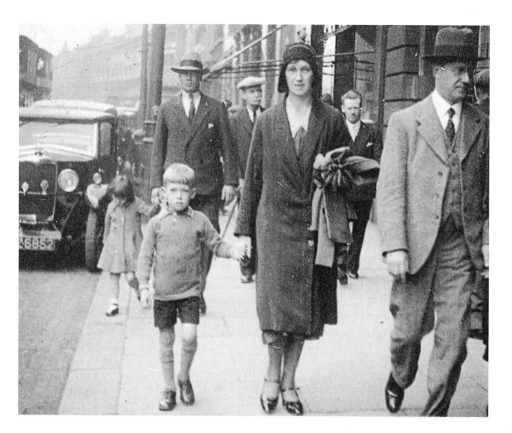

James in Belfast with his mother, father (back) and sister Dorothy, 1932

a cap, jersey, short trousers, socks and boots. His American outfit, wrapped in a brown paper parcel, was tucked under one arm. Later, when some of the gang spied what they took to be an interloper foolhardily sashaying alone down the street, they sped off in pursuit, only to find that the stranger was a yankee.

'Tom,' they yelled. 'We didn't know you. Boy, would you look at him.'

They gathered around him in a bunch, pulling the cap down over his eyes.

'My knees are freezing,' Tom complained, which left them falling about laughing.

Quickly accepted, Tom became an honorary gang member. We always insisted that someone accompany him if he strayed too far from Brookmount Street. The thought of our yankee friend being picked upon or shoved around by eejits from a couple of streets away was something we would not tolerate.

Our roller skaters boasted a few show-offs who considered themselves to be a notch or two more talented than the rest of us. Hopping kerbs, snaking around lamp-posts, hanging onto each other's jersey tails, they belted everywhere, yelling at the rest of us to make way. The poor persistent stragglers, never upright for long, suffered endless jibes.

However, a serenely moving expert now slipped quietly alongside. He would propel himself backwards with remarkable ease in large figures of eight, then turn on two wheels and race forward performing perfect circles across the street. And the speed he could move at! Our fancy skaters' mouths hung open as they watched. Tom Irvine also possessed skates the likes of which we had

never seen. They boasted ball bearing wheels and adjustable steel shoe grips at the front, with leather padded straps over the ankle. And, if you spun the wheels they would run noiselessly for ages, smooth as silk. By comparison, our cast iron wheels would squeak, wobble a few cumbersome rotations and grind to a halt. A more serious fault was that a solid bang against an immovable object could shatter the wheels to pieces.

At Tom's good-natured insistence we queued, one by one, to bust our necks on his innovative roller skates. Feet deserted us and arms thrashed skew-wiff, as the wheels slid butter-like beneath us. Faring no better than the rest of us, upended and disgruntled, the show offs met their Waterloo to the accompaniment of yells of derision. It was lucky that no one broke an arm or a leg. We all agreed that Tom's skates were the bee's knees. We felt very discontented with our iron clodhoppers. A long, long wait of two years was to ensue before ball bearing skates arrived in the Belfast shops, just in time for Christmas.

Molly and Tom's sojourn in Belfast lasted six weeks. Two days before sailing back to New York she organised a goodbye party for Tom at the Johnston house. Wee buns, sweets and lemonade filled our gobs and the kitchen door lay wide open to the street, an invitation to anyone who wished to say their farewells. Tears were tripping a few, not us of course, but the grown-ups. We could see them dabbing their eyes and hugging the breath out of Molly.

I promised Tom that I would write and I did. The letters sailed backwards and forwards between us for nearly four years when suddenly there was a long gap. I wrote again, but still no response came from him. I asked the Johnstons for news of Tom and was told that he had been very ill and was still poorly after weeks in bed. Tom never wrote again and never returned to Brookmount Street in my time.

One Halloween, a student teacher appeared in our classroom. She was golden-haired, pretty and smiled and chatted to us in a soft country brogue. We loved her instantly. Among the subjects she taught was handicrafts and she burned with wonderful ideas for making things. A snipping of cardboard and a stirring of wallpaper paste, which she made in a basin and dolloped out to us in jam jars, was often the only sound in the classroom. We made Halloween masks and hats and everyone became totally absorbed with painting their creations in gaudy poster colours. I was enthralled and elaborated even more on her ideas by sticking layers of cardboard, one on top of the other, and building up devil horns by twisting paper and stiffening them with glue. In class, I became famous for my ghoulish masks and one day the young teacher, after seeing a sketch book, asked me what I wanted to do when I grew up. Without hesitation I told her I wanted to be an artist.

A week passed in a flash and we enjoyed the student's company immensely. She was a real contrast to our class teacher, Miss McCandless, whose grumpy

countenance and uncertain temper was our usual lot. To our way of thinking, Miss McCandless and Mr Abraham were from the same mould.

But soon came the student's final morning of teaching practice and it proved to be one that was long remembered. Miss McCandless, after admonishing us to be quiet and to behave ourselves, had vanished, leaving the student in charge. A soft tap on the classroom door made us swivel our heads to see who was there. No one ever knocked and we were immediately curious. The student looked puzzled too but she opened the door and to her obvious surprise a man of about her own age sidled through. He was wearing a huge grin. They had a quick, whispered conversation, then she turned to the class.

'Children, this is a friend of mine,' she said.

'You mean your boyfriend,' chirped an impudent voice.

A titter rippled around the room and we regarded the pair with unabashed interest as they stood smiling at each other. Suddenly he leant forward and, grabbing her by the shoulders, kissed her smack on the mouth. For an instant there was silence and then the room erupted with laughter and the young teacher blushed a deep rosy pink. She put a finger to her mouth pleading for silence as she pushed her friend towards the door. He never made it.

James with Bonzo his rabbit, 1932

With a face like thunder and his bushy eyebrows knitted together in a frown, in walked Mr Abraham. He took in the situation and, pointing at the young man, ordered him out and then told the student to leave the room as well.

'I want silence in here,' he barked as he made to follow the young couple into the corridor. We fidgeted as we waited and eventually a worried looking student returned to the classroom accompanied by a stiff faced Miss McCandless who was clearly seething with suppressed anger.

Whatever had transpired outside the classroom we never discovered and a very subdued atmosphere settled over the class as the morning dragged by. However after lunch the student seemed to have recovered her usual cheery spirits and even Miss McCandless's face occasionally cracked a thin smile. About fifteen minutes before the end of the school day, the student addressed the class, thanking us for being so nice to teach. We were astonished. No one had ever thanked us for anything. She then reached under her desk and brought out a big cardboard box of dolly mixtures, which she opened and proceeded to pour into individual paper cones and then handed one to each of us. As I was leaving for home she called me back and suggested that I try modelling in plasticine and with that she handed me a note for my ma with the same suggestion.

Ma read the note and some time later, on her return from one of her shopping forays to Belfast, she gave me a box of terracotta coloured plasticine. My first ever attempt at sculpture captured Bonzo, my rabbit, chewing a carrot.

'Show it to your father when he comes home,' said ma.

I interpreted this as praise for she never commented on my artistic efforts.

A sprinkling of snow had earlier dusted the street but, to our chagrin, the flakes had ceased to fall and the dark threatening clouds had scudded away leaving a cold clear sky. Christmas was only a week away and not one of us could remember a white one. Jonty, bored trying to scoop up snowballs, suddenly quit and slowly blew his breath into the thin air where it hung motionless. To the accompaniment of much jigging around, he delivered his opinion that it was going to freeze hard later and that the road would be like glass.

Winter darkness was looming as a trudging lamplighter flicked on the gas mantle switch, casting a circle of yellow light around us, and Archie Robinson sidled up. 'My da slipped on the snow in the yard and slashed his leg,' he sighed. 'He bled like a stuck pig and couldn't go to work.'

Archie didn't seem too fussed by his da's misfortune. Come to that Robby, as he was nicknamed, rarely fussed about anything. Sometimes we thought him a bit thick in the head. Robby went on, 'He wouldn't let my ma send for Doctor Haddick, so the oul country cure woman next door boiled up hot water and threw a handful of salt in. Then she soaked a bandage and slapped it around my da's leg. Ma says you could have heard the yells and shouts of him in Battenberg Street.'

Robby's da worked for an undertaker but in what capacity no one was sure. He never discussed the intimacies of his profession with anyone. Every morning he would throw his leg over an old battered bicycle, a duncher slanted low over one eye, his long shabby grey overcoat flapping behind him and pedal slowly off to work. One day, however, neighbours standing in silence paying their last respects to a passing funeral, suddenly gawked in astonishment at the sight of Mr Robinson attired in a tall black hat, long black coat and shiny black shoes, walking slowly beside a huge horse-drawn hearse, resplendent with glossy black paint and gleaming glass windows. His air of pious dignity acknowledged no one.

Every street seemed to harbour an old woman who constantly watched, listened, poked her nose in where it wasn't wanted and chose the least opportune moment to declare her opinions. Miss McKinstry was ours. She tortured us children with a torrent of complaints, threatening to inform the police, not the peelers – nothing so vulgar – for she regarded herself as a cut above her neighbours. She lived a solitary existence behind her curtained windows and she pushed neighbourly relationships to the limit of tolerance. God help them, the long suffering Robinsons lived next door to her.

We gathered from Robby that Miss McKinstry said the leg was badly poisoned and needed a hot linseed poultice. 'Da's still screaming blue murder in there. He says there's no hairs left on his leg.'

Suddenly the crone herself appeared from nowhere, wrapped up like an Eskimo and wagging a warning finger at us. Her shrill voice pierced the night air and she complained that we were making too much noise and told us to take ourselves off.

The gang shuffled around in a hostile group, reluctant to disperse and muttering amongst themselves.

'What's that you said? Cheeking me up, are you? I'll put an end to this.'

Her temper and voice rose rapidly and she stepped gingerly over the frosted ground towards her house, returning minutes later with a bucketful of ashes and a shovel. We stood speechless and open mouthed, watching her scatter shovelful after shovelful of grey ash all over our beautifully burnished ice slide. Then humphing triumphantly to herself she disappeared indoors. Angry scowling faces promised retribution whilst we discussed whether or not to make another slide.

The bright moon was suddenly obscured by a flurry of dark clouds and a coldness gripped our bare knees, persuading some of us that maybe we should go home, read a comic and toast ourselves in front of the kitchen range. But Jonty, still smarting with rage, came up with an idea for revenge that was irresistible and the whole group took off down the street and turned up the back entry where we peed all over Miss McKinstry's back door, kicked it a resounding blatter and ran off, yelling with satisfaction.

Later, I warmed my frozen toes on the kitchen range and told ma about Mr Robinson's sore leg and Miss McKinstry's cure, careful to leave out any mention of the slide and our revenge. Ma was of the opinion that Mr Robinson was too stingy to pay for the doctor and that Miss McKinstry ought to have more sense than to meddle.

Next day Robby did not turn up for school and it was late afternoon before I ran him to ground. He was full of his da's woes.

'I had to take a note about him to Doctor Haddick. His leg's in a bad way, all yellow and swollen up. My uncle Tommy called last night to cheer him up and brought him a wee whiskey for Christmas. He thought da's leg looked terrible and poured the whiskey over it. He said the leg needed it more than da did. Then uncle Willie came later and said the leg was a real mess and needed cleaning out, so he poured turpentine over it. Ma said da nearly fainted and he moaned all night long and she never shut an eye. This morning when he came the doctor gave off stink and wanted to know was there anything they hadn't put on his leg and who was playing doctor. Then Miss McKinstry walked in. God, he chewed her head off. Ragin' he was. Sent her packin'. Told her to keep her cures to herself. She won't come back for a while, ma says. The doctor bandaged my da's leg up and told him to let nobody near it and he's not allowed to stand on it or to go back to work for a week.'

'What's your da say?' I asked.

'He's ragin' about payin' the doctor and losin' a week's wages. He's not

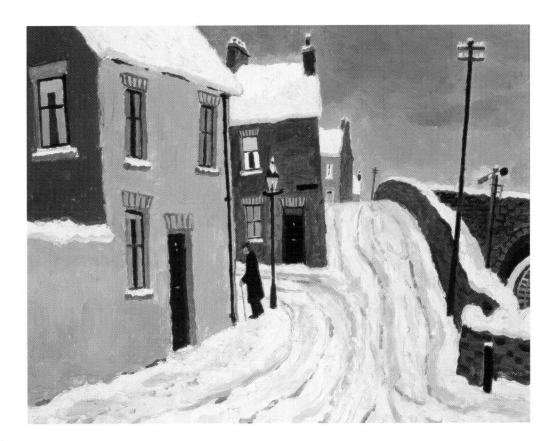

talkin' to anybody,' said Robby.

Snow, 1950

My ma's ears flapped when I told her. 'The stupid, silly man. And as for that nosy woman next door, I'm glad to hear she got a clearing out. Dr Haddick's not behind the door telling you what he thinks,' she asserted.

On Christmas Eve snow flurried on a gentle wind and grew deeper by the hour. At the corner of Brookmount Street faint strains of a carol being sung by some members of the church choir huddled around a swaying lantern, drifted over the still night as I sank into sleep. Next morning I slowly blinked myself awake. Hearing the whisperings and fidgetings of my little sister Dorothy and I as we searched in the dark for our Christmas presents, ma appeared and lit a candle for us and then ambled sleepily back to bed, hoping for another hour of oblivion. Much later I heard her rattle the embers of the kitchen range as she made her preparations for a hectic Christmas Day's cooking.

As daylight came I was suddenly aware of how quiet the outside world seemed. Everyday street sounds were absent. Not even the rattle of a tram could be heard as it struggled up the Shankill Road. Cautiously, I raised the window blind. Icicles, frozen on the corners of the window frame, silted in ice-crazed mosaics. Through the misted glass I stared in wonder at a world of pure whiteness. Against a brooding steel grey sky, snow sagged in drifts over rooftops, chimneys and backyard walls. It clung precariously in every nook and cranny; even the washing line anchored above our bath tub trailed a skein of white. Below me in the yard da had shovelled away a path to the lavatory and

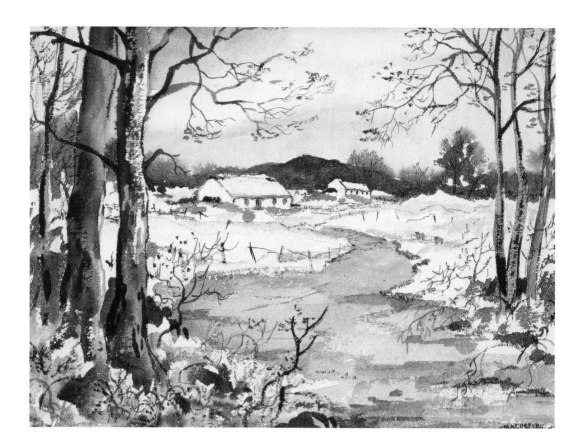

the encircling black tarred strip on the wall was nowhere visible. Gleefully I reckoned the snow would reach my knees.

In winter our upstairs rooms were chronically damp and chilly and I shivered as I dragged my clothes on in a flurry of arms and legs. Dodging the washing hanging limply on the landing, I tore downstairs and, as I let myself out, I found our street struggling to life as people cleared snow off their passageways, shovelling it across the pavement onto the road. Even the birds were silent and invisible. They must still have been sheltering in their roosts, plumages puffed up for warmth. My Christmas stocking contained a thick watercolour pad, brushes that smoothed to a beautiful point when wet and a glossy black tin full of artists' watercolours. These were colours unlike anything I had previously used and I itched to try them out.

The snow, lying deep over our backyard, entranced me and later I sat at the kitchen table and stared out, whilst attempting to paint the brick wall and gleaming rooftops. So many things baffled me. I noticed the absence of shadows replaced by just a tinge of pale blue whilst everything else seemed opaque, dark and dramatic. Finally, after lots of mistakes, I completed a small snow scene and my ma propped it up on the mantelpiece. Snow scenes became one of my favourite subjects. I revelled in the strange colour contrasts of winter landscapes that the snow somehow enhanced.

A week later, on New Year's Eve, dirty snow was still puddled in the streets, frozen into treacherous tracts, and delivery men toiled through it with grim faces, hours late with their rounds of milk, bread and coal. Our parents

grumbled about it. They were tired of the inconvenience and longed for a break in the weather. However our gang harboured no such notions and we enjoyed every single day. We fought snowball battles, built towering snowmen and sleighed in Woodvale Park using home-made contraptions. We were heedless of the discomforts of blue frozen fingers and pinkish purple noses and ears that stood out against our pale pinched faces. Mr Robinson had meanwhile limped to recovery, endlessly lamenting the loss of a week's wages and the cost of the doctor's fee. The sight of his old boneshaker of a bicycle, resting idly against the backyard wall because he could not ride to work through the deep snow troughs, and the fact that he had to fork out good pennies on tram fares, provoked him further.

'Serves him right,' said ma unsympathetically.

That year ma had promised that I could, for the first time, sit up late to listen to the wireless and hear in the New Year. The wireless spun music while ma sat knitting, reading and listening all at the same time and I lounged on the sofa, stifling yawns and forcing my eyes to stay open as I fought sleep.

Then ma said, 'Quick, open the back door, it's five to twelve.'

Timed to the second, deep sonorous ships' foghorns blasted the night air. A cacophony of sirens, whistles and church bells joined in a chorus that reverberated over Belfast. Faintly, in the distance, I could hear people yelling and shouting and singing their hearts out.

'That's "Auld Lang Syne",' said ma. 'It's 1935 now.'

2

In 1935, to celebrate the Silver Jubilee of King George V, the pupils of Woodvale Primary School were given a free tram ride to Bellevue, free entry into the zoo and free rides on the ghost train and dodgems at Hazelwood Park. Long afterwards we talked about our adventurous day and everyone agreed it had been a smashing trip.

Then, two years later, in May 1937, we were given a two day holiday to mark the coronation of King George VI. A coronation mug and a free trip to wee Joe's flea-pit halfway down Shankill Road were the authorities' contributions this time. The gang compared this stingy offering with the last treat and asked each other why we could not have been given tickets to the much closer and more luxurious new picture house, The Savoy, on the nearby Crumlin Road. We all agreed that we would have swapped our mugs and the visit to the cinema for another trip to Bellevue.

Less than three weeks later, on 12 June, a mist came down over Divis Mountain and the surrounding countryside, and a catastrophe occurred. A Royal Air Force plane flew straight into the side of the mountain. The pilot lost his life, a tragedy we street urchins heartlessly gave but little thought to. We had only one objective and this was to climb Divis and view the wreckage. When I told ma where I wanted to go it took much wheedling to get her to agree. By coincidence, a film called *Hell's Angels*, a First World War epic of

aerial dogfights had recently had us glued to our seats in the cinema. For days afterwards the street hummed as we flew around with outstretched arms, pretending to machine gun everyone out of the sky.

That afternoon a vast canopy of overhanging foliage dappled bright sunlit patches over Glencairn Road as five of us passed Inkwell House, so-called because of its shape. We were heading for open countryside and the slopes of Divis Mountain. As ever, Hookey, searching for crawlies, lagged so far behind that we left him to his own devices. Gradually the road dwindled to a rutted lane and we passed what seemed to be the last hillside farm. We were very thirsty and debated asking for a drink but the farm looked neglected, with no sign of anyone, so we passed by in single file, on up the rising ground of scattered whin bushes and bullrush covered fields. We had but one topic of conversation – aeroplanes and their design. Arguments grew steadily more contentious the higher we climbed. Jonty, who would have fought his shadow, became very belligerent.

We had all seen the film, but certain details, especially the episode with the machine-gun mounted above the cockpit which spat bullets straight through the propeller, was a subject of much bellicose debate and its mechanism, little understood by any of us.

'My da,' insisted Jonty, 'says it did shoot through.' So we demanded, if that was true, how come the propeller wasn't smashed to bits?

Jonty hopped around all agitated. 'You callin' my da a liar?' he yelled.

We came upon a vicious barbed wire fence and, one at a time, manoeuvred our way over it. The hot sunshine poured down upon us as we eventually collapsed in a heap, searching the humped skyline two or three hundred yards away for signs of activity. Far below lay Belfast, enveloped in a hazy blanket of smoke with only the tall chimneys and shipyard gantries poking through. On the far horizon the Mourne mountains were a smudge of pale blue.

My little notebooks of sheets, tied together with thread strung through holes, were carefully constructed to fit my jacket pocket. Often, leaning against a lamp-post or sitting in Woodvale Park, I made discreet sketches, being careful not to attract attention to myself. The gang, accustomed to my oddities, would ignore me as I sat drawing and only Hookey ever asked to see what I was doing.

Now Jonty, bored with inactivity, rose and cajoled the rest of us to march forward. The ground, baked solid and cracked by summer sun, enabled us to tread without hindrance ever higher. Then, from nowhere, a piercing blast from a whistle shattered the silence stopping us dead. On the rim were three peelers gesticulating like puppets and indicating in no uncertain fashion that we should turn back. Jonty, furious, stood his ground in defiance then hoisted a couple of fingers at them.

Loud shouts split the air as the three peelers galloped downhill after us. We scattered in a mad scramble towards the barbed wire fence. The fence posts

shook and wobbled with the combined weight of four of us climbing the wire to launch ourselves into the next field. Harry Elliott, a fraction behind, had just cleared the top wire when it snapped backward, a vicious twang striking him across the backside. A yelp of anguish rang out but we kept on running towards the lane until Jonty stopped and yelled out that the peelers had given up on us. Harry stood silent, his face screwed up in pain, and when he turned around two large triangles of ripped trousers hung down. His shirt tails, already stained a dark red, poked through and blood trickled slowly down his legs.

'He's cut his knobs off,' screeched Jonty and we almost believed him.

Carefully we lifted Harry's shirt tails and across both cheeks of his bum we saw two long weals oozing blood. Harry's tears flowed copiously as panic slowly began to mount within us and we stood around undecided about what to do next. Then, from around the bend dandered Hookey, hands dug in pockets, peering short-sightedly into the hedgerows. We waved and yelled at him to hurry, perhaps hoping that Hookey's clever mind might find a way to ease Harry's predicament.

Had it been one of his crawlies Hookey could not have examined the bum more gently. He declared the scratches not deep and suggested that if Harry ceased to jump around the bleeding might stop. 'Bring him down to that house,' he said. 'I've been talkin' to the farmer who owns it.'

Hookey always had more wit than all the rest of us put together.

The front of the farmhouse looked dilapidated, but at least it was all in one piece, while the rear propped itself up with the weirdest collection of sheds and outhouses imaginable. They extended far beyond the house and were

mostly made of corrugated iron that was rusted and gaping with holes. At some time this farmstead must have been a busy thriving place but now all I could see were a few sheep grazing on nearby slopes, a cluster of cackling hens and a pig grunting and poking about contentedly.

Hookey, very obviously, had already been inside the house and he led us unhesitatingly through a doorway, the lintel of which sagged and bowed so much that I half expected it to collapse. At the end of a long dark hall Hookey opened a door into the living room. A cheery little man, a white stubble of hair over his face, sat by a massive open fireplace which was black with soot, while suspended on a long chain over the fire, a steaming kettle merrily rattled its lid. The man removed his pipe to reveal about three teeth and spat an arc of juice that splattered far short of the hearth. Not only was the room generally filthy, it was plain that it hadn't seen fresh paint and wallpaper or had its windows wiped in years. In the corner a flight of stairs sagged in the middle and looked ready to tumble down at any moment.

We stood there gaping and saying not a word. The place was an absolute shambles and even Harry forgot his injured bum for a few seconds. Hookey introduced us to Charlie, owner and sole occupant of this crumbling pile and explained Harry's mishap. Charlie told Harry to haul his trousers down and lie bum up on the table.

'This is an old sailor's remedy,' he said and produced a tin filled with a white greasy cream which he gently spread over Harry's tender backside. He then cut two lengths of bandage and pressed them gently over the scratches which at long last had stopped bleeding. When he had finished Harry inched his way

Peat, 1949

off the table and slowly drew up his trousers whilst Charlie produced safety pins to fasten the torn flaps.

'That will keep you decent till you get home,' he said.

In this sorry house were some very odd things. The tongue-and-groove ceilings seemed to run at an angle, the long mantelpiece, adorned with various items, rose at one end and the fireplace alcove sloped outwards at the bottom. Nothing seemed vertical. Even the chair legs were at odds while pictures, covered in dust, hung slightly askew. It seemed as though the whole house and everything in it leant sideways. Charlie's home, perched on the windswept slopes of Divis, fascinated me.

Seated around the big table, Charlie handed us cups of tea and pieces of bread and jam which vanished in a flurry of grabbing paws. Harry's bum rested gingerly on a thick moth-eaten rug and he seemed much more comfortable. Charlie told him it was a good thing he had cut his bum now and not next year because by then Charlie wouldn't be around to play doctor. We wanted to know why and he told us he was going to sell the place and move to Sailorstown as the farmhouse was too lonely in the winter and the nearest pub was miles away at Ligoniel.

Charlie's parents and two brothers had run the farm when, at sixteen, Charlie left to join the merchant navy and sail the world for forty years. Like himself, his brothers had never married and, consequently, he had inherited the farm about seven years back.

'It was a mess then and it's worse now,' he said. 'Only worth knocking down but I'll get a few quid for the land and buy myself a wee house next to the docks where I can watch ships sail in and out and maybe meet some of my old shipmates.'

The sticky heat of early afternoon had waned somewhat and Harry began to fidget. He wanted to go home. So we thanked Charlie for his kindness and as we said goodbye Hookey and I asked him if we could come back again.

'Anytime you want. I'll be here for a few months more but gone by Christmas,' he told us and spewed a mouthful of tobacco juice which landed inches from Jonty's feet. We set off and found it easy going downhill all the way home. However, Harry began to fret about his patched trousers and his ma's reaction.

'Don't worry,' said Jonty laughing. 'It's your ass she'll be more worried about.' Harry reminded him that his bum was torn open only because Jonty had given the peelers two fingers. For once Jonty had enough wit to shut his gob.

The evening *Telegraph* carried the story of the aeroplane that we never saw. A Hawker Fury bi-plane, capable of two hundred miles per hour, had underestimated the summit of Divis by twenty-five feet. Had the pilot been forty yards further away, where there was a dip to one side, he would have cleared the mountain. The pilot's name was McMath and he had been on a flight from Cattfoss in England to Aldergrove. His Squadron Leader was George Beamish,

one of four brothers who joined the RAF. Both men came from Coleraine where my family originated.

For a week after our adventure Harry had to sleep on his stomach. To his delight he missed school as well because he wasn't allowed to sit on a hard bench. One day he yanked his trousers down so that we could see his scars. Right across the bum were two scabby lines. Somebody said it looked like a hot cross bun. This inspired him to show off his 'hot cross bum' for a halfpenny a time until one day he displayed it to some girls and his ma got to hear of it and thumped his ear holes.

Hookey and I visited Charlie another three times over the summer months. Hookey went crawly hunting and I spent my time drawing hens, sheep and ramshackle sheds and felt really pleased with myself. I gave Charlie a watercolour of his house which he said he would hang in his new place. One day about three years later as I cycled along Royal Avenue, who should I see but Charlie, all cleaned up and wearing a suit and polished shoes and sporting new white teeth. He told me that he now lived in Henry Street, a woman came in and did his washing and cleaned for him two or three times a week and he had fallen in with some of his old shipmates. He was a happy man and I wished him well.

West Belfast Orange Hall, at the top corner of our street, came to life for only one week in July when its scattered members gathered to celebrate their big day, the Twelfth. I had actually never witnessed a Twelfth parade, the reason being that at the beginning of July every year, da would pile ma, himself, my sister Dorothy, me and the luggage into his latest road machine which in 1937 happened to be an Austin Seven. Ma considered this car to be a great improvement on its predecessor which had boasted a folding top that was always loath to unfold itself in the event of a sudden downpour.

Both my parents came from Coleraine, where I was born in one of a row of thatched cottages known as the Irish Houses on the Crannagh Hill. My father's family seems to have spent their lives flitting to and fro between Scotland and Ireland until eventually, most of them settled either back in Scotland or in Canada. My mother's family had found themselves suddenly uprooted when my grandfather, a Permanent Way Inspector on the Northern Counties Railway, was transferred in 1929 from Coleraine to Greenisland. Ma still had a married sister, aunts and friends living in Coleraine and at Burnside near Portstewart. Our annual summer excursion was principally so that ma could visit her relatives and enjoy her old haunts. It also allowed us youngsters to dig sandcastles on Portstewart strand.

At the end of a high-banked winding lane at Mullaghacall near Burnside, in a long, low, thatched cottage with extensive outhouses and a doorway surrounded by a spectacular flower called Lobster's Claw, lived ma's Aunt Annie.

Other plants flourished in a higgledy-piggledy riot of colour on either side of the path. At the back a latched gate opened onto a field, often dotted with black and white cows, which rose gently to a hillock of trees. The cottage always gave me a feeling of pleasure and every year I looked forward to visiting it even more than I did the beach. I loved the overhanging trees, the wild garden and beyond it the field where roosters strutted and crowed and hens clucked and pecked. I loved the outhouses which were stuffed with machinery and hay and, the peaty aroma of great Aunt Annie's low ceilinged kitchen was a smell I never forgot. Hung from a crossbar and chain, suspended above the fire, was a black kettle that was constantly on the boil and from which the teapot would be filled over and over again while ma and Aunt Annie locked heads as all the news passed between them.

Great Aunt Annie was a lady of substantial width who was given to bear-like hugs that nearly crushed me to death. When she gave a hearty laugh everything shook, rose and fell and I half expected to see her voluminous clothing split and fall apart. Early on fine mornings and accompanied by her black and white collie dog it was her custom to stroll down to the beach. There she would remove her outer clothing to reveal a vast red and white striped bathing costume and would wade into the surf where she and the dog would splash around to their heart's content. She told us that on one such morning while

Whitehead, 1947

she was thus cavorting, three young bucks had arrived on the beach and at the sight of her yelled, 'Hey missus, you're bustin' out of that tent!'

She had come out of the water like a charging bull waving her fists and had sent her collie after them. 'Cheeky young pups,' she said, laughing at the memory.

Now ma had considerable trouble keeping her face straight at the thought of Aunt Annie frolicking about in the water and later when she told da about it he quipped that she could have been the original model for the McGill funny postcard beach lady.

Situated on the edge of a golf course, our holiday home had originally been a wooden trailer of the type pulled along behind huge steam engines and used as living quarters by the engine driver and his mates. Refurbished, and with a new coal-burning stove, a three-ringed paraffin cooker, a washbasin and bunk beds, it was almost a home from home. It sat ten minutes from Portstewart strand, and twenty minutes in the other direction flowed the river Bann on whose banks my da spent most of his time fishing. Often of an evening I watched a blood red disk streaked with bands of gold and orange slide majestically below the wide arc of the Atlantic and I sighed over my inability to capture the sight on paper. Some day, I thought, I will paint a sunset in all its splendour that will be good enough to please me.

James in Portstewart with his father and sister Dorothy, 1933

For six consecutive summers my da trundled us over miles of bumpy road at a steady twenty-five miles per hour, sometimes passing a saluting AA man with his yellow motorcycle and sidecar. Among my peers I considered myself a fortunate person to have a yearly holiday. Most of the gang never went on holiday at all except for a Sunday School day excursion or a trip to Bellevue Zoo and they were lucky indeed if they achieved that. Money in the days of large families was tight, with little left over for frivolities.

As usual when I returned from holiday little evidence remained of the Twelfth celebrations. Gone were the flags, bunting, barriers and even the Orange Hall had assumed its demeanour of sombre dignity once again. A huge blackened scorch mark where the eleventh night bonfire had been was usually the only sign of the festivities. Hookey told me that Jonty, in the thick of piling rubbish onto the bonfire, stood where he shouldn't have and lost the hair of his eyebrows and scorched his fringe. His face shone like a beacon for a week, his suntan better than mine, and to crown it all his ma half killed him.

Near Brookmount Street lay another stretch of ground which served during our long summer breaks from school as a place to fly kites, dig treasure holes and hide-outs, play Cowboys and Indians and sail paper boats or fire missiles at marauding rival gangs across the banks of the Blackstaff river. We called it the meadow. I could easily imagine the meadow as it might have been a hundred years ago; a haven of tranquillity with cows grazing on its lush pastures, ambling down the grassy banks of the river to drink. But the green fields were gone now, replaced long ago by a huge bare cinder football pitch, surrounded by terraced houses and a factory.

The single crossing over the river consisted of three thick planks supported by a concrete pillar in the middle. At times of heavy rainfall a torrent of dirty water would sweep downstream, cascading over the bridge and making it impossible to use. But to the gang the deluge acted like a magnet, tempting us to scramble foolhardily along the river bank. At times some of us were fortunate not to have been swept away.

A constant file of people crossed over the bridge on their way to and from work. When the flooding made that impossible they were forced to backtrack onto the Shankill Road. On these occasions workmen from Mackie's Foundry would give vent to their frustrations by a very ripe use of the vernacular.

Set far back from the river and running parallel with it was a long low factory wall beside which, on most Sunday mornings in summer, a group of men ran a thriving pitch-and-toss school where often considerable amounts of money were wagered. Peelers constantly harassed them and a sixpence could be earned by keeping a look out for their appearance. A loud whistle from the watcher scattered the men and sometimes the money was left untouched, such was the scramble to escape. To keep watch, some of the gang mitched Sunday morning church. Ma declared it a shame and a disgrace that grown men should entice youngsters away on a Sunday to indulge gambling habits. My

da, a policeman, replied that if that was all they got up to on a Sunday it wouldn't worry him.

The meadow, on long summer evenings, also drew the doggymen out to exercise their greyhounds. Sometimes when as many as four dogs were gripped together they could prove a handful. Usually they were quite docile animals but if a cat were to suddenly shoot out in front of them the racket they made was terrible and the handler would be nearly dragged off his feet. One of the gang, Jim Johnston, no relation to Jonty, had started gambling when he was nine years old and had bought his first greyhounds at fourteen. He had had to borrow his da's long trousers to get into Dunmore Park, the dog racing stadium on race nights. Eventually he made a career in dog racing. The local men sometimes played horseshoes or pitch-and-toss and we youngsters watched with interest as money very unobtrusively changed hands. Jonty often tried his best to muscle in but was always told to take himself off and spend his pennies on sweets.

Pitch-and-toss

Our meadow, these few hundred yards of waste ground behind Battenberg Street, offered us the chance of adventure which we pursued in all our different ways. At times it could be downright dangerous, at others quietly absorbing, but for some youngsters and grown-ups who rarely left the confines of the surrounding streets it gave a little pleasure which cost nothing but time and we always seemed to have plenty of that.

Early in December I received a tremendous surprise by post. I was over the moon about it. As a winner in the junior section of the *Belfast Telegraph* drawing competition I had been awarded a ten shilling postal order – an absolute fortune. For hours afterwards I wandered around in a daze contemplating and congratulating myself on my sudden wealth. Being a prizewinner in an open art competition meant much more to me than just the money. It raised hopes and gave me inspiration – at last my efforts had been recognised in some small degree and I felt hugely encouraged and pleased. My school teacher, more concerned with academic subjects than art, said with not too much enthusiasm that she was glad to hear of my achievement. I knew she would have been more impressed if I had won an arithmetic competition instead .

The gang goggled at my winnings but if my parents felt any delight at my success very little of it showed on the surface. However, I discovered later that

my aunts and uncles had heard all about it so they must have felt some pride. The unexpected win cheered me no end and the following year I won another postal order.

Knockagh, Greenisland, 1938

Belfast docks,
1946

3

Talk of another war with Germany began to spread among our parents
and neighbours. At the cinema on the Movietone News we young-
sters watched Chamberlain on his return from Munich deliver a
speech about 'peace in our time'.

We had seen the Spanish Civil War on film but most of us had decided that
as it had all happened in a foreign country it was too far away for us to worry
about. Then Hitler began to appear on the newsreels with his arm stuck in the
air as battalion after battalion of armoured soldiers passed before him. We heard
even more worried talk amongst our elders. Da was very unhappy about Hitler
and each time he heard his name mentioned on the wireless he would mutter
something to the effect that Hitler was 'itching for another scrap.'

War between Britain and Germany was finally announced on 3 September
1939, just twenty-one years after the last slaughter had ended, and gloom
descended on our community. A blackout operated immediately. As well as
street lighting, the ban included light from all windows, particularly skylights
and glass front door panels which had to be hung with heavy dark curtains or
paper blinds. On the first night of it I stood with the gang on the Shankill
Road waiting patiently for complete darkness to fall and when it did we were
immensely impressed by the eeriness of it all. However, the blackout was
only the beginning and was soon followed by sundry instructions from the

government. Identity cards and gas masks were issued and every so often a mock air raid siren test was operated just to keep the population on its toes. Food rationing was introduced and, most serious of all as far we we were concerned, sweets were rationed. We knew then that war had really begun.

When I left school in May 1940 I wanted to be an artist but, I hadn't the faintest idea how to realise such an ambition, I was happy with the thought of being a telegram boy. I fancied myself riding around Belfast on a red bicycle with the regulation dark blue pillbox hat on my head, delivering important telegrams. Unfortunately my total failure to pass the Leaving Certificate examination, whose paper was littered with algebraic and mathematical conundrums far beyond my comprehension, put paid to even this aspiration. No pass, no career as a post office employee and, of course, no red bicycle.

My ma, now that I had finished with school, was determined that I was not going to be allowed to follow my inclination and sit around all day painting and drawing and she announced one morning that our backyard walls needed a coat of whitewash. I was dispatched with a huge tin bucket to the Shankill Road lime kiln and a while later I staggered home, done in, with one arm nearly paralysed and my fingers numbed purple by the sheer weight of the lime lumps.

When water is added and stirred into lime the mixture splutters, hisses and bubbles like a witch's cauldron. Ma, always to the point, warned me of the dire consequences of not paying attention to what I was doing. 'Mind your eyes, that stuff could burn a hole right through them,' she said cheerfully.

Three days later I stood in the yard and admired my handiwork. In the late afternoon sun the walls gleamed pristine white and around the bottom a neat black border one foot high set them off. Ma beamed her pleasure at the sight and was so effusive in her gratitude that I took the head staggers and offered to paint all the yard doors a dark glossy green. I finished the lavatory door last and then painted the big iron cistern and the down pipe and finally the lavatory seat. After tea and with sixpence from an appreciative ma in my pocket, I set off up the Shankill to meet my pals in Woodvale Park where we spent the time larking about until the insistent shrill of the park attendant's whistle warned us that he was closing the park for the night.

Sauntering homewards Jonty had only one thing on his mind – his interview for an office boy's job at a downtown ironmonger's shop the following week. Normally a boisterous and stubborn character and quick with his mitts, a nudge of apprehension made him quieter than usual as though he had begun to realise that life after school might be a trial just beginning for him – and the rest of us.

Our terrace house with its blacked out windows seemed very still as I opened the front door. The hallway, even in daylight, had always been gloomy but became darker than ever after ma pasted a stained glass paper sheet over the fanlight. Warm gaslight flooded the hallway as I opened the door to the kitchen. Da, as usual, sat bolt upright in his massive captain's chair, puffing away at his pipe, his head wreathed in whirls of tobacco smoke as he read. Ma, however, looked as though she was sitting on a bed of nettles and pounced on me immediately, demanding to know why I had not told her that I had painted the lavatory seat. She had sat down on it in the dark and declared that her bum was raw from scrubbing it with turpentine.

'And your father sitting there grinning like a Cheshire cat,' she added, glaring at us both. I was expecting a clout around the lugs but she settled herself uneasily into a well padded cushion and listened as I explained how I had thought that the paint would have dried by the time anyone went into the bog. Da looked at me, lips twitching, rolled his eyes and switched on the wireless.

A week later Jonty was striding around in great form, back to his usual cocky self. A weekly pay packet of five shillings would soon be jingling in his pocket and, if he behaved himself, a chance to serve an apprenticeship at sixteen. Then he told me something else.

'I got word from Greeves's Mill about a job. You want to go in my place and tell them I'm working?'

'What kind of job?' I asked cautiously.

'Does it matter? It's a job, you eejit,' he exclaimed. 'They want a message boy and you have to deliver letters around Belfast, that's what it is,' he said.

'On a bicycle?' I asked hopefully.

He looked at me as if I had ten heads. 'It wouldn't be a friggin' horse, would it?' he answered in exasperation.

I thumped him on the arm – anywhere else and he would have flattened me. 'That's great, Jonty,' I said excitedly and belted home to tell ma.

Ma's expression and very obvious lack of enthusiasm wasn't exactly encouraging and I listened as she listed her objections. I hardly knew my way around the city centre streets and had never ridden a bicycle downtown in my life. Trams, trucks, cars and cart horses would be milling around me in all directions and, on rainy days, I would be soaked through from morning to night.

All the same, I could tell that her protest was half-hearted for to ma's mind any job was preferable to having me running wild around the streets. Ma did not tolerate idlers gladly so I knew that if da would agree she would give in. He did.

Greeves's spinning mill was a massive Victorian shoebox of red bricks slotted with endless rows of windows that peered over the crowded back streets of the

Falls Road. It wasn't difficult to find. At the gatehouse window I was directed to an office crammed with clerks all scribbling in thick black ledgers. Acutely aware of lifted heads and stares, I threaded my way past desks to an office in one corner of the room. At the sound of my discreet knock a figure, crouched over his desk, raised a hand and beckoned me in without looking up. Giving me a brief glance he asked, 'William Johnston?'

'No sir,' I replied. I had decided in advance that I would address important looking people as 'sir'. 'I'm James MacIntyre,' I went on and hesitantly explained Jonty's absence.

He listened carefully, asked a series of questions about my background and then asked if I had any hobbies. I told him I drew and painted and was a Boy Scout. At this the interview turned into a discussion about art which lasted for about ten minutes and then he told me the job was mine and shook hands with me. I was told to report to Miss Trimble at the gatehouse on Monday morning. The hours were from 7.45 am until 6 pm and the wages were four and sixpence a week. Then he held out an envelope and asked me to read the address on it and write it down. I did so and he nodded approvingly. Apparently my predecessor had gone out on his first run, returned two hours later still in possession of the mail and got sacked because he couldn't read or write.

Passing the huge gatehouse clock I noted the time. Come Monday morning I needed to be there at exactly 7.45 am so I timed the one and a half mile walk back home to the minute. The office manager had intrigued me. He certainly seemed to know a lot about art history which impressed me and he had mentioned smudging pencil and charcoal drawings and had asked me how I shaded mine.

When I arrived back home and opened the kitchen door the broad smile on

my face must have told ma everything. She listened in a non-committal way as I described the interview in detail. Her only interest was in knowing where I would be delivering letters and what time I was to start in the mornings. I expected a minor uproar over this as I knew that she would have to be up at the crack of dawn to feed me and get me out of the door by 7.15 am. 'Oh well,' she said, 'that's not so bad. Your uncle John used to work from six in the morning until six at night. You can keep one and sixpence a week for yourself,' she added as an afterthought.

I smiled to myself. I had a job and contemplated what my first week's wages would buy. I wouldn't be riding a red bicycle, just a black one with a panel between the framework that said J & T.M. Greeves Flax Spinning Mill in white letters. It suited me fine and I couldn't have been happier.

Our street gang, once a tightly-knit bunch who together had climbed the foothills of Divis, rambled up the Glencairn Road, played football and other games, fought rival gangs, gone to the pictures on Saturdays, strolled reluctantly to school everyday, broke windows, hung onto the backs of trams, raised mayhem at Halloween and had our ears blattered for misbehaving, was now slowly drifting apart. We were breaking away one by one to pursue other interests. Now the sixteen-year-olds were serving their apprenticeships, sneaking off to the pictures with girls they had previously never looked twice at and were openly smoking. We younger ones taunted them over their choice of girlfriends and roundly berated them for the miraculous change to pressed trousers, nifty ties and Brylcreemed hair. Some played snooker, darts, gambled at the dogs or learned to dance and the really keen Boys' Brigade and Scout members were more active than ever. Some, to our utter disgust, lost their heads completely. One took to religion and spent every evening at the gospel hall praying for our souls and declaring that he was never again going to the pictures. 'Imagine anybody not wantin' to go to the pictures,' cried Jonty incredulously. We could not envisage survival without the flicks.

We gradually acquired deeper voices, sprouted hair all over the place, and grew tall like summer weeds. However, one boy remained strangely immune to all the growing male eccentricities surrounding him. His voice still remained an octave higher and there was not a blackhead or pimple in sight. He filed his nails to perfection, patted his groomed hair into place and sashayed along with little mincing footsteps. Ma said, 'Keep away from him.'

I didn't know what she meant.

At precisely 7.45 am on the Monday morning following my interview I arrived at the mill. Women, arms linked together, hair curlers tucked beneath their headscarves and men, dunchers perched at all angles, were already wandering through the mill gates bantering away with each other.

Miss Trimble, a dumpy slightly forbidding person, pointed towards another lad across the yard and told me. 'That's Billy Brown. He'll show you what's to be done.'

Billy Brown, I quickly discovered, came from Sandy Row. He was a cheery-faced tousled-haired comedian, blessed with quick-witted Belfast humour, who knew Greeves's Mill inside out and everyone of importance in it. Since he had been a messenger boy for the past year, every street and establishment in Belfast was familiar to him as well.

The sudden blast of a raucous hooter startled the wits out of me and Billy pointed towards the huge double gates. We rolled one half shut while Billy explained that the horn was to let everyone know that they had three minutes to get to work. At exactly eight o'clock the hooter wailed again and the remaining gate closed. Latecomers used a side entrance and Miss Trimble made a note of their names and their pay was docked accordingly. For ten minutes the gates remained shut and stragglers arriving after the gates reopened would lose a whole morning's pay. Billy often stood out in the street, watching the clock, frantically waving people to run for it as the seconds ticked away. Many times Miss Trimble fumed as Billy, ignoring her frantic signals from the gate-house window to shut the gates, still continued to hustle breathless latecomers through. She often threatened to report him but never did. 'Must have had a ruckus with the boyfriend last night,' was Billy's explanation for her frequent bouts of temper.

A fortnight later I discovered to my cost the hazards of cycling in Belfast. One morning at Castle Junction the tram lines seized my front wheel and I was almost catapulted over the handlebars. Always cross the lines at an angle I had been told. Laid at various strategic points around the city centre were wooden square sets. Originally designed to minimise the impact of the clatter of horse traffic on church services, they were a near lethal menace for unwary cyclists. On wet days, slamming the brakes sent rider and machine skidding away in a flurry of arms and legs and my dignity received a hefty shock when it happened to me, but I did learn a lesson.

I enjoyed my job except on long days of unremitting rain. Then I would return from a delivery with hair plastered flat and rivulets of raindrops tricking down my neck, over my raincoat onto my legs and finally dribbling into my shoes. I looked and felt like a drowned rat and ma kept telling me that sooner or later I would catch my death of cold.

Every morning I picked up the delivery mail from Fred Thompson, the office manager who had interviewed me and sometimes our conversation would turn to art.

One evening at quitting time he asked if I would bring along some of my paintings for him to see. So next morning I did, leaving a pile on his desk. His favourable reaction to them delighted me and he wanted to know who had taught me.

'Nobody,' I said, embarrassed. 'I just spend hours at it.'

Fred's encouraging words came at a very timely moment. Lately I had become bogged down with watercolour washes that refused to do what I

expected of them. On my cycle runs I would steal time to jam my nose against Magee's Art Gallery window in an attempt to fathom the mystery of how Frank McKelvey accomplished his confident washes. His obvious expertise with a paintbrush depressed me even more but not enough to contemplate giving up my own efforts.

One morning a short time later Fred quietly told me to close the office door because he had something to show me. He motioned me towards the desk and opened a thick-backed folder but kept one side upright to shield its contents should anyone walk in and disturb us. On the first page a pencil and charcoal drawing of a nude woman stared back at me and I felt my ears go pink with astonishment and embarrassment. It didn't seem to me to be very well drawn in places but it was nicely toned and the overall effect looked not too bad. I knew right away it was by Fred's hand. He turned over the pages and each portrayed a nude woman stretched out on a long sofa and my initial embarrassment began to subside only to be overtaken by another predicament. I wondered what in the name of God I was expected to say when the last page was reached.

He was more than twice my age but I sensed that he sought my opinion and I was so embarrassed that I was tongue-tied when he closed the book and looked at me. I guessed that I was probably the only person at the mill ever to see his drawings and I told Fred they were great and then asked who the woman was.

'My wife,' he answered, and then asked me not to mention the subject to anyone else.

Of course I had seen paintings of nude women in books many times and from what I read I knew that every artist needed to draw from models to

Nude sketched by James, 1947

understand human anatomy. I wondered briefly what ma's reaction would be if I ever I got to that stage.

I long remembered Fred Thompson for being the first person to indicate that he thought that I, perhaps, possessed some talent for painting something my teachers had never done.

Gradually I fitted into my job, aware of every nook and cranny in the mill - spinning floors, workshops, stores, offices, engine room and a labyrinth of stone stairways worn by countless feet. I discovered places that beguiled me over and over again. One such spot was the pattern maker's bench which held objects carved in wood by a master craftsman. These pieces were carved from a solid block into cogged gearwheels, flutelike columns studded with holes, panel pieces with swept curved edges and intricate corners. In fact, any worn or broken piece of machinery was reproduced in wood by the pattern maker and later cast and machined.

Albert, a stooped figure with glasses hanging off his nose, was a kindly man and always found time for me and my badgering questions. 'Well, young MacIntyre,' he would ask in his soft country accent, one of the few in the mill, 'what part of Belfast city are you off to the morning?' 'Nowhere Albert, I'm just visiting,' and I would stand and watch as his chisel shaved tiny slivers of wood which curled into ringlets.

Many times as I watched Albert working I pondered on what a marvellous way it was to spend a life. Woodworking lurked in my genes. My family harked back to the Scottish MacIntyres who were hereditary woodcarvers and it did occur to me that should art fail to fulfil its promise I could accept a career in woodworking.

About twice a week I would take Albert's models to a casting foundry on the Grosvenor Road. The foundry was a gloomy structure of shadows, smoke, steam and hot metal smells that stung the nostrils. At the back the furnaces burned fiercely, piercing the tenebrous space with luminous hues. The workers, heedless of the background mayhem, toiled away in silence. Often I lingered longer than I intended, unable to drag myself away from a painter's paradise of movement, shadow and intense brilliant colour. Long afterwards I turned one my doodles done on the spot on one such visit into a painting which was eventually hung in an exhibition at the Ulster Museum.

In July the mill shut for the Twelfth holidays and already I was itching to get away on the first summer Scout camp to Ballywalter. Petrol and food rationing severely curtailed our activities and we were fortunate to discover a lorry driver willing to transport our equipment and some Scouts to Ballywalter. A cache of tinned food, tea, sugar and so on, donated courtesy of each Scout's ma had slowly stockpiled over the last three months. We prayed for a sunny dry week and thought that if necessary a daily feed of mashed spuds and scallions would suffice us. Our campsite sat behind a large farmhouse and the farmer's wife on previous occasions had supplied the Scouts with an abundance of fresh farm

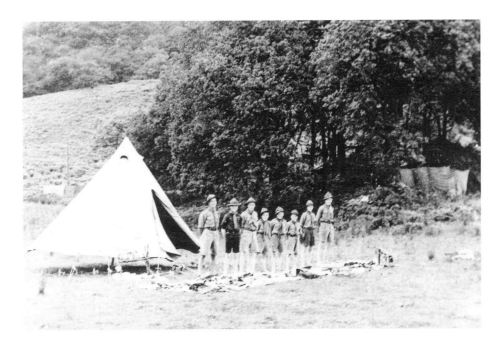

produce. But now with strict food rationing in operation we could only hope that our daily basics of milk, eggs, butter and spuds, would somehow materialise.

Scout camp at Ballywalter, 1942

A few days before the mill closed for the holidays, ma suggested that I call on my way home with grocer James McMullan and ask for a large box.

'What for?' I asked.

'Your rubbish. I want it all neatly packed with nothing left lying around before you go camping.' By 'rubbish' ma meant my precious paints, brushes, pads and mounds of paper. She continued matter of factly. 'We're flitting next week to a three-storey house in Woodvale Avenue and I'm giving you an attic room for yourself and all your stuff. When you get back from camp everything will have been moved. The house has electricity and a bathroom so I don't want to hear any more excuses for not washing properly.'

I thought I wasn't hearing right. A room all to myself for painting? An attic studio like real artists had! My head whirled with the images that shot through it. All that day, oblivious to everything as I cycled around Belfast, I tried to imagine the appearance of the attic. I made plans to buy some wood to make a desk with a sloped top and to ask my da for advice on how to go about it. Then, somehow, I would acquire an easel. I hoped the attic would be big enough to hold all this treasure. Yesterday, ma's kitchen table had contained my world of paints and brushes and even that was only available to me at certain times. I stored my 'rubbish' in the glory-hole under the stairs and beneath my black iron bedstead. Now I would have my own room which I could use at any time and where I could shut myself away in peace and solitude and make a world of my own. And, most importantly, when I left it I could close the door, unmindful of the orderliness or otherwise of any 'rubbish' heaped behind it.

Sometimes surprises occur and this one I reckoned I could cheerfully live

with, but I did wonder why I had not heard a whisper in the family of any intention to flit. Sudden decisions, especially one of this proportion, were rarely taken in our house. Ma ticked over like the Albert Clock, geared and timed to the minute, and she loathed upheavals. I could only reason that consultation was not something which concerned my ma and da.

Camp week was all that we could have desired. The hot sun scorched our skulls and pinked us all over and we ran around with nothing on but gutties and trousers. Each morning we would build and light our fires while the grass was still heavy with dew and we fried our eggs, soda farls and potato bread as the wood smoke rose and gently wafted itself into the clear air. At night when the temperature dropped and stars studded the dark heavens, we heated stones on the campfire and wrapped them in newspapers to warm our toes, snug in our home-made sleeping bags which were held together with large safety pins. However, after a week of sleeping on uneven ground the pleasure of a warm bed and soft pillows was fully appreciated and we returned home happy, sun-burned and full of beans.

When I first saw it, my attic studio filled me with delight. Almost square, with a little rounded embossed cast-iron fireplace, complete with tiled hearth in one corner, it overlooked Woodvale Park. The window, which faced westward, flooded the bare floorboards with light. It was exactly what I had hoped for. Ma eventually bought a piece of linoleum and a high stool to go with my home-made desk and in time it began to look a little less spartan. I adorned its walls with paintings and drawings and fantasised to myself about eventually being able to entertain my friends if I ever acquired enough money to furnish it further.

The new house was enormous compared to the old one in Brookmount Street and although the kitchen window and backyard faced the blank gable-end of another house, ma pronounced it a great improvement. At times, I think ma was homesick for her country origins, especially when mist, rain and heavy black clouds settled on the Shankill Road rooftops. These were the days when her claustrophobic surroundings would dishearten her and she would regale me with tales of the Irish Houses and the surrounding landscape stitched with thorn hedges. However, Woodvale Avenue at least fronted trees and open parkland and I could see from my studio its grandstand, where local bands entertained passers-by on long summer evenings. And I'm sure ma appreciated the amenities of modern living which were a far cry from the simple cottage life of the past. I left Brookmount Street behind forever and I wasn't the only one. Hookey's family had moved house the previous year, also to the Woodvale area, but when our schooldays finally ended I saw him only rarely.

After the holiday I returned to the mill reluctantly and on the first morning I recounted to Billy all the previous week's happenings. He was very jealous of

our new house as he said his was like a hen house with everybody crammed together like sardines and he wished all his big sisters would clear off and get married.

The winter months approached and with them came the downpours. These were the bane of message boys' lives until one particular morning, with rainwater streaming off us, we marched together to Fred's office and demanded that the mill provide us with us sou'westers, capes and leggings. We must have made some impression on Fred for less than a week later, Miss Trimble, grumpy as ever, informed us that he wanted to see us in his office and opined that he was probably going to sack the pair of us. But minutes later, all grins we returned, each carrying a complete waterproof outfit and proceeded to don them in front of Miss Trimble.

In winter the blackout caused many casualties, especially if heavy fog added to the blanket of darkness. Visibility could be reduced to four or five feet – one night I walked smack into a telegraph pole and bounced back, my head spinning.

The trams fared very badly. The drivers, being unable to see or distinguish landmarks never mind the stops, were often forced to have someone walking in front of the trams to guide them. This resulted in long queues of trams and in some areas the whole system almost came to a standstill. Fortunately, very few cars ventured out after dark. By law their headlights had to be covered and reduced to a narrow beam and my da often said that this was the cause of many injuries and some deaths. Billy and I, even in the dead of winter, always made certain our afternoon runs finished before darkness fell.

Woodvale Park

The morning began just like any other morning and it seemed quiet and normal. Ma pottered around making breakfast, packed my lunch and sent me on my way to work. But that evening the front door was opened for me by my Aunt May. Now in the normal way of things Aunt May ought not to have been there as she and my granny on their occasional trips to Belfast always visited at lunchtime. I was instantly suspicious and as I looked at her it became obvious that she knew something I didn't and the knowledge, whatever it was, tickled her no end.

'Your mother has a surprise for you,' she said coyly. 'She's upstairs.'

Uneasily I followed her upstairs and waited as she pushed open ma's bedroom door. I peered into the room and my jaw dropped for there, propped up on pillows, was ma with a baby in her arms.

'You've got a wee baby sister, isn't she lovely,' whispered Aunt May, cooing like a turtle-dove.

Had the roof toppled in it would have been less of a shock. I stood tongue-tied and goggle-eyed in disbelief. I tried desperately to think of something to say and finally managed to croak, 'Where did that come from?'

They laughed at me but I got no answer to my question. I had, of course, been vaguely aware that women got fatter when they were pregnant but I had honestly not noticed any great change in my mother's appearance and there certainly had been no discussion of the forthcoming arrival in my hearing. Still, I supposed it was a grown-up affair, kept like a classified war secret for certain ears only. That and the move to Woodvale Avenue. But I did think that they might at least have given me some indication of the expected event.

My little sister was born on 11 March 1941 and was named Patricia.

After a week of tending to the needs of the MacIntyre household Aunt May's stamina began to wane. Da seemed to be permanently on night duty and asleep during the day and Aunt May had trouble getting through the household chores which ma usually took in her unflappable stride. In her young days ma, a personal maid in a large house in Coleraine, had I suppose, been thoroughly trained in household management. Aunt May, in ma's frankly voiced opinion, lacked fortitude.

When things became difficult she customarily developed a headache and was prone to taking to her bed at the slightest excuse. Now, completely exhausted, she staggered off home to Greenisland and ma slowly resumed command again.

Drawing from James's sketchbook, 1941

Bored during lunch hours, Billy and I and a few machine apprentices would sometimes take ourselves to one of the derelict spinning rooms on the top floor of the mill, to play around with a rubber ball and generally amuse ourselves. One particular day things became a bit boisterous and we began

throwing wooden bobbin pins at each other. The commotion we made was probably louder than we were aware of and in the fracas no one noticed that a door had been flung wide open by a highly irate foreman who charged after us as we fled.

It was my bad luck to be the one he was able to grab as the others disappeared through double doors at the far end. I was marched to his downstairs office and told in no uncertain terms that my job was in jeopardy if I refused to name the other offenders. He disappeared for ten minutes and returned with the mill manager who was furious at having his lunch break disturbed and I was ordered again to name the culprits. I asked whether they would be sacked too. This riled him no end and he informed me through clenched teeth that his decisions were none of my business.

'Well, I'm sorry to leave the mill,' I said, 'but I'm not having my mates sacked because of me. I'll collect my cards and go now.'

Downstairs I went, told Miss Trimble and Billy what had happened, visited Fred and Albert for the last time and walked out, sacked from my first job. I went home and told the story to ma. Her typically pragmatic response was, 'I never liked you riding that bicycle around Belfast anyway.'

Just a week later, circumstances far beyond my own making would have compelled me to leave the mill in any case.

Behind the park railings a gnarled chestnut tree spread its heavy branches, thick with spring buds, over the ugly and massive air raid shelter which had been erected opposite our house. Da put it bluntly.

'Should there be an air raid when I'm on duty, none of you are to use that shelter. If a bomb landed close to or onto the concrete roof nobody would live through it. It's a death trap. Use the bunker downstairs.'

I knew that da, a much shelled veteran of the First World War, understood the hazards of dugouts and shelters better than most people and I reckoned that his was good advice and that, if necessary, I would take it. Months previously he had bought four inch square timber lengths, built a framework of uprights and crossbars and reinforced our stairway glory-hole turning it into a bunker. Ma received strict instructions to always keep it clear of rubbish and he predicted that even if the house did collapse we stood a better chance of surviving beneath the stairs than anywhere else. Invariably he referred to the rest of us and excluded himself and I wondered where he proposed to shelter if there was an air raid.

Da said that if incendiary bombs did fall they would be likely to lodge either in the roof space or in top floor rooms and he insisted on keeping the stirrup pump and buckets of water in the attic, rather than in the outside bog. He was also adamant that no one should chuck anything into the water buckets to block the stirrup pump.

Each evening he would cycle to Oxford Street where on the flat roof of the Court House he and other policemen manned Lewis guns in the defence of Belfast against attacks by the German bombers.

Quite a few times over recent months the raucous sound of wailing sirens had stopped everyone in their tracks and on one particular night in the Scout hall, just after Christmas, they blasted off again and we stood silent, looking at each other, undecided whether to stay put or run. That time nothing happened and there were so many false alarms that most people began to assume that Belfast was far beyond the reach of Luftwaffe bombardment. That is, until one afternoon in April 1941, a single plane crossed high over Belfast and da, who always treated the Germans with great respect, observed that if one plane had made the journey others would soon follow. That same night at around midnight, as I lay in a heavy sleep, I was suddenly awakened by ma literally shaking the daylights out of me. 'Get up!' she yelled. 'It's an air raid!'

Dad (left) and a colleague at Peter's Hill, 1950

Though barely half awake I knew by her agitated state and the way she rushed around the bedroom pitching clothes at me that the war had finally touched Belfast. 'Get dressed and down the stairs,' she shouted, hauling me out of bed.

I could hear people running and shouting around the back of the house. In the distance, from somewhere downtown, a long slow crump floated over the night air and after it had subsided, the pulsating drone of aircraft could be distinctly heard. I dressed frantically, upending myself in an effort to find a trouser leg in the pitch dark and rushed upstairs to peer out of the back attic window.

Fountains of yellow flame burnished the sky above the distant shipyard and dense smoke fanned by a breeze billowed upwards. As I watched, horrified and unable to draw my eyes away from the destruction, another enormous bomb exploded. From down below ma screamed for me and as I flew headlong downstairs I distinctly heard two thuds outside in the street.

Ma was crouched in the glory-hole with my tiny sister, barely a month old, cradled in her arms while Dorothy sobbed quietly behind her. I told her I was going outside for a minute to see what was happening.

'Stay where you are,' she screamed. 'Bombs are going off.'

'I won't be long.' I replied and bolted.

Already I had got myself into a lather thinking that incendiaries had landed just outside our door, but deliberately said nothing, knowing that ma would work herself into an even greater frenzy. As I opened the front door our next door neighbour staggered past, weighed down by a sandbag clutched in his arms.

'Two incendiaries down, one round the corner,' he grunted with exertion. 'Grab another bag.'

Outside his front door one incendiary, half covered by a sandbag, still spewed

flames and he heaved another bag onto it which split open and completely extinguished the fire bomb. The second bomb had fallen between the two gable-ends and hissed and shot sprays of flames, like a fire cracker gone mad, halfway over the roadway. I struggled and hauled a bag up to belly level and it seemed like a ton weight as I staggered crab-like across the roadway up behind the bomb. I could feel its heat as I approached and quickly dropped the sand-bag over it and ran. A spume of white smoke shot out and the incendiary splut-tered and died. In the half moonlight I stood well back and watched, realising that had the device fallen on our roof and into my studio, an inferno would have engulfed the entire house in no time. Hairs rose on my neck and for the first time I began to realise the enormity of the danger that these incendiary bombs posed.

Our neighbour rushed over, worried and apprehensive, saying that only two incendiaries seemed to have dropped and that since they usually fell in clusters he wondered where the hell the others were. A few people hurried past on Woodvale Road and further up our street some men appeared. One steel-hel-meted ARP officer ran down to check everything and told us that more incen-diaries had buried themselves in the park and brick fields beyond. I heard a long sigh of relief and I guessed we had encountered the tail end of the clus-ter. Then I remembered ma. As I rushed home somewhere in the far distance I could hear anti-aircraft guns pumping a staccato boom boom and a succes-sion of explosive eruptions split the night air. When I entered the house I expected a tirade of abuse but ma seemed to have succumbed to exhaustion and distress and said remarkably little, only asking if I had seen any of our neighbours.

Ma brooding in silence worried me much more than her occasional out-bursts which I usually shrugged off and forgot. In the torchlight we huddled together like peas in a pod and and occasionally I slipped outside and listened for sounds of abeyance. For hour after hour the bombs kept coming and I think it was around four in the morning when the sirens finally sounded the all clear. As we crawled to bed exhausted ma said, 'I wonder where your father is?' The same thought had crossed my mind more than once but I had decid-ed not to say anything.

Most mornings at around eight o'clock da would arrive home from his nightwatch but this morning, ten o'clock had come and gone without any sign of him, and ma became convinced that some terrible calamity had befallen him. About eleven o'clock and unable to sit around a minute longer doing nothing, I told her that I was going to the Shankill Road police station to ask them to find out where he was.

The upper Shankill seemed free from bomb damage but I could see that a heavy pall of smoke still hung over the distant shipyard. When I reached the top of the steep hill at Shankill Road library I saw da coming towards me, wearily pushing his bicycle. A smudge of dirt blackened one side of his face

and as he drew nearer I noticed what appeared to be bloodstains on one shoulder and down one side of his greatcoat.

His first question was about things at home and I reassured him that we were all fine but that ma had been climbing the walls worrying about him.

'Are you OK?' I asked him.

'Well,' he answered in his laconic way, 'I could do with a good feed and a bit of shut-eye.'

I asked him about the bloodstains on his clothes and he told me that he had carried a man who had suffered serious shrapnel wounds from a landmine explosion to a first aid post. He told me that the Luftwaffe had repeatedly strafed with machine-gun fire the courthouse building where he and his comrades had been manning their weapons. When the final wave of bombers arrived they were machined-gunned again and a landmine was dropped in the dock area but failed to explode. He said the Germans had done a thorough job of flattening the area around the shipyard and Short and Harlands the aircraft factory, but that Belfast city centre was mainly intact.

As we trudged together up the Woodvale Road he said wearily, 'Oh well, it's over – for now.' I took his bicycle from him and pushed it the rest of the way home.

I stored the bicycle in the shed in the backyard and minutes later I entered the kitchen to find da warming his backside in front of the fire and listening as ma recounted last night's events. She had composed herself remarkably well and I felt much relieved to hear her chide me for tearing around outside in the thick of things. Life seemed to be returning to normal.

Early that afternoon the sound of our front door knocker echoed down the hallway and when I opened the door I was surprised to see my cousin Day Parkhill and his friend Roy Houston standing there. I ushered them into the kitchen where ma stood gawking at them.

Drawing from James's sketchbook, 1941

'What's wrong?' she asked in alarm.

Day assured her that everything was fine but that granny had sent him and Roy to fetch us all down to Greenisland. Day and Roy worked in Shorts but all staff had been turned away until further notice because of the bomb damage. Ma thought for a while and then started to pack our suitcases while I jammed my Scout rucksack full of my possessions, not forgetting pencils, pens, ink and a drawing pad.

Woken by all the commotion, da appeared downstairs and he and ma had a brief discussion about domestic arrangements. Luckily, Granny McKirgan possessed a phone so ma would be able to ring the barracks. She cooked a huge meal and da wolfed it down, lit up his pipe and watched us as we locked the suitcases and staggered out of the front door. He accompanied us to the tram stop, carrying ma's suitcase, which he placed in the space beneath the tram's staircase and then stood by the tram stop as we rattled away, downhill towards the city and York Street railway station. There we found, not surprisingly, that the trains were not running on time and that long queues of people were shunting with agonising slowness towards the ticket window. When we did manage to pass beneath the ornate iron barrier and finally board the train, we discovered that there was standing room only and that was in the guard's van. We were fortunate to have even that.

Eventually, the engine raised a rush of steam and the train threaded its way over the points and built up a rhythmic clickety-clack as it rolled towards Greenisland. When we at last arrived at granny's house it took a while to sort out where we were all going to sleep and, of course, granny ruled the roost and delighted in bossing us all about.

One afternoon da used up the last of his month's ration of petrol to drive out to Greenisland and unload another consignment of odds and ends for ma. Before the war started he had bought the car, a Ford 8, almost new for fifty-five pounds and, as we had no garage, he kept it in the barracks at Brown's Square.

'Great runner,' he would say wryly. 'Pity I've no petrol to turn the wheels.'

A week after fleeing Woodvale Avenue the sirens wailed again and before they ceased we could already hear tremendous explosions over Belfast. From the back lane behind my grandparents' garden we had an uninterrupted view across open fields at the terrifying conflagration of Belfast. The devastation spanned the breadth of the harbour estuary and overhead the night sky swirled and danced in fiery reflection.

We knew that somewhere in the middle of this mayhem da was at his post and in granny's house we were filled with trepidation.

When dawn came, Belfast was engulfed in deep layers of smoke and everyone sat around restlessly, downing endless cups of tea. I knew that they were all praying for a phone call from da. It was Easter Tuesday 16 April 1941.

The phone rang around one o'clock and mats flew across the hallway in the

mad rush to answer it. Everyone stood, silently glued to the floor, as my Uncle Jim lifted the receiver.

'Is that you Jimmy?' we heard him ask. 'Are you alright?'

He turned towards us as we clustered in the hallway and raised a thumb in the air. I heard ma let out her breath and could feel the sense of relief that descended upon us.

However, we quickly understood from the tone of Uncle Jim's conversation that things were very serious. Da told him that a bomb had exploded in the street directly behind our backyard and three houses had been demolished. Every window in our house had been blown inwards, glass splinters embedding themselves deep in furniture, doors, bannisters and even the walls of the house. The front door had landed in the street and the back door smashed a chunk out of the kitchen window ledge as it was blown off its hinges. Apart from that da said, with his usual flair for understatement, the rest of the house was still standing. That afternoon he planned to board up the ground floor windows and replace the doors. Ma was told to stay put and on no account come to Belfast. There was nothing to be done. He would clear up the broken glass and stack it in the yard.

Anyway he added, York Street station had been bombed, trains only ran to Whitehouse and no trams were operating along York Street at all. He promised to come to Greenisland at the first opportunity but it was five days later before he at last arrived. We heard then that all the windows in our house had been replaced with roofing felt as it would be at least three months before glass became available. There was not a chink of daylight in the place and so the electricity had to be on in daytime as well as in the evening. He said it was like living in a dungeon. In time utility glass did become available. It was opaque and impossible to see through but at least it allowed daylight to filter into our house once more.

Da's experience of the Easter Tuesday blitz must have been appalling. He later summed it up as being 'a bit hairy' and then laughingly told us that the District Inspector had spent the night hiding below in the basement. Da was always inclined to underplay things and we sensed that the long night must

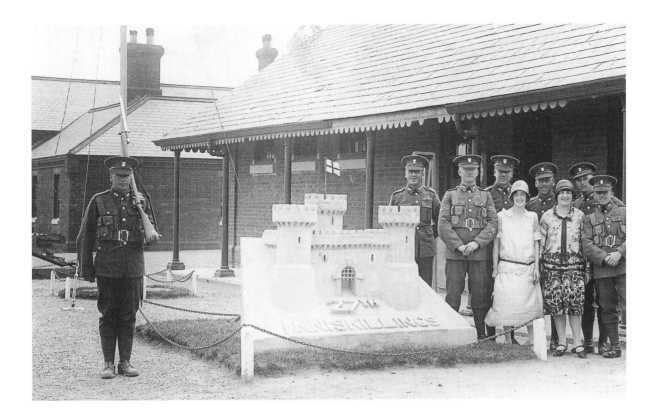

have been a grisly experience which he did not want to dwell upon. Having enlisted in the Royal Inniskilling Fusiliers in 1914 he had survived the rigours and horrors of the First World War and succeeded in earning himself a chestful of medals including the Military Medal and Bar. The Bar is awarded for exceptional bravery. Da had won his Military Medal for crawling out from his position during heavy shellfire on three separate occasions in order to drag wounded comrades back to the comparative safety of the trench. He saved the lives of two privates and an officer in this way. After the rescue of one of the men, as they sat just feet apart in the trench, a shell landed between them. It was a dud and failed to explode. The Bar to his Military Medal had been awarded because for a period of six hours during a barrage bombardment, he had again crawled out of the trench during gaps in the firing to repair lines of communication. He was later offered a commission but declined it. The rest of his long life was lived at a gentle pace and it was only rarely that he allowed anything to unduly upset him.

Dad (left) in the Royal Inniskilling Fusiliers, 1920

Granny McKirgan's back garden,
1950

4

I was almost skint except for a couple of shillings that one of granny's neighbours had paid me for sawing down a tree and chopping its branches into firewood. Even worse, I missed my studio and by the sound of opinions being voiced all around me, I wouldn't have it for quite a long time. Still, I reflected, our house had escaped serious damage and I should be thankful we still had one to go back to.

Three weeks had passed since the Blitz and I nagged ma incessantly to be allowed to go to Belfast to see the destruction for myself, but ma was adamant that I stay put and was deaf to all my appeals. I was tempted to make an illicit trip to the city, taking my sketchbook with me, in the hope of making a few drawings on the spot and I briefly considered risking ma's wrath to do so, but the thought of facing both her and granny filled me with a certain caution. My granny was a fearsome spectacle when her bile was up!

Granny's semi-detached house bustled from morning to night with the serious business of baking, ironing, washing, cleaning and cooking meals in between. Visitors would appear at all hours to chat and would sit drinking god knows how many cups of tea. Most evenings the men of the family would go out, leaving the women behind to gossip as they sat knitting, darning socks or sewing. Since clothing coupons were required for every wearable item, nothing was heedlessly discarded. Shirt-tails were snipped off and remade into new

collars, old pullovers ripped out and re-knitted into all manner of things. And trapped in the middle of this domesticity I found it impossible to have five minutes alone at the kitchen table in order to sit and draw. Even the budgie plonked in its cage enjoyed more personal space than I did.

Beyond grandpa's garden gate the back lane, which had started life as a packhorse route centuries ago, straggled and twisted up and over Knockagh Mountain and into the hinterland of the Antrim plateau. In a little secluded valley, tucked beneath Knockagh's rim, lay Anderson's farm which was mentioned in the 1811 edition of Miskimmon's *History of Carrickfergus* as being beside the Silverstream and the western boundary of Carrickfergus. Many times over the years I had climbed up to Anderson's. Our families were well acquainted and I was given complete access to draw and paint on their land. I found the old house in its magnificent lofty setting, its even older leaning sheds and barns and the air, filled with animal noises, entirely fascinating. I would spend hours there, absorbed and contented.

A rutted lane, flanked by outhouses that jutted and leapfrogged towards a gateway at the far end, rose behind the house. One day I found that the lane was blocked by a corrugated iron fence and, undeterred by the unexpected barrier, I nonchalantly hopped over it. I was barely halfway along the path when the air was split by excited, high-pitched squeals. From an open shed door a batch of piglets shot out and tore madly around in circles. From the same doorway grunting noises heralded the appearance of a muddy snout, followed by a massive head and two beady eyes

Granny McKirgan, 1950

Pig and cottage, 1950

which instantly fixed themselves upon me. For long seconds the sow and I stood motionless, just looking at each other until I, possessed until now with the notion that pigs were clumsy, ungainly creatures, given to lolling harmlessly about in mud, suddenly had a change of mind forced upon me. With head lowered and ears almost dragging the ground this one grunted louder, farted, spun its tail, scattered screeching piglets out of its path and, flinging mud in all directions, charged me like a wild boar intent on a kill. For a twinkling I stood rigid, eyes out on stalks and then in a mad skelter of flailing arms and legs I fled, pursued by a dozen shrieking piglets and their outraged ma.

I cleared the corrugated iron barrier at a racehorse gallop and heard the furious rattle as bodies impacted to the accompaniment of an unholy din of piggy affront. As I stood trying to catch my breath I was suddenly aware of the sound of laughter. Jim Anderson, doubled over with his hands resting on his knees and tears streaming down his face, had appeared as if from nowhere.

'I watched you heading up the lane. I knew what would happen,' he said between belly laughs. 'By God, you came back in a hell of a hurry,' and he gave me a good-natured dunt on the shoulder that was meant to settle my ragged nerves.

It was my first, but certainly not my last encounter with the hazards of the farmyard, for which I soon learnt to keep open a wary eye.

Granny's domestic routine required me to climb Knockagh twice a week. The first time to Anderson's for eggs and then to Jane Hagan's farm on Knockagh's east side for a can of buttermilk. I once tried to do both errands on the same day but tumbled over a fence, lost half a basketful of eggs, spilled all the buttermilk and returned shamefacedly to face a tongue-lashing. To make matters worse I had acquired a long tear in my trousers.

Between the two hill farms, close to the rocky base of Knockagh, an ancient cave hid itself behind a shrubbery of rampant hazelnut trees. In past times the

Sketch of Knockagh, 1947

steep path leading to the mouth of the cave would probably have been quite wide but erosion, and the propensity of this part of the Antrim plateau to land-slips, had made it almost impassable and only after much effort did I manage to haul myself inside the entrance to the cave. I unloaded my rucksack, spread a spud bag on the ground and leaving my sketchbook aside I sat gazing through the curtain of hazel branches, mesmerised by the thought that generations of ancient peoples had once lived here, lit fires for cooking, warmth and protection and roamed the countryside hunting and fishing.

In the early eighteenth century a notorious rascal called Naoise O'Haughan, a highwayman, was reputed to have hidden in this cave on many occasions as the military searched the countryside for him. He robbed travellers and stage-coaches around the foothills of Divis to Carnmony and Carrickfergus and led the military a rare dance for many years until he was finally apprehended in 1720 and hanged at Gallows Green near Carrickfergus. Legend had it that some of his loot lay buried at Knockagh and just to satisfy my curiosity I searched every inch of the cave but, of course, found nothing.

Enough of the landscape appeared between patches of hazel foliage for me to sketch the broad acres and the lough far below. A string of at least twenty cargo ships were anchored on the horizon at Bangor Bay and had been for weeks past. Great was the speculation among the locals as to what they were doing there. Sitting on the spud bag and with my legs dangling over the edge, I picked up my sketchbook and made a drawing of the ships. When I had finished I shut the sketchbook and prepared to make my way down the hillside. Not without some difficulty I reached the rocky ground below. This visit to the cave proved to be my only one, for when I returned to the area months

later, I discovered that there had been another landslide which had left crumbling scree and few footholds. Only a practised climber with proper gear could reach Naoise O'Haughan's cave now.

Sketch of the aftermath of the Blitz. York Street Railway Station, 1941

One morning, after almost two months of anticipation, I finally accomplished the journey to Belfast. I got off the train at York Street and stared around. The wooden and glass canopies above the platforms of the station had completely disappeared and the iron pillars that had supported them now stood forlornly open to the sky. The once elegant hotel was completely destroyed, the marshalling yards were gutted here and there and parts of the forecourt and station entrance were also badly damaged.

I walked up York Street for a bit and saw that Gallagher's tobacco factory was still standing but that the huge bulk of York Street flax spinning mill, the biggest of its kind in the world, was now just a shell and the little mill houses that had clustered in its shadow had been reduced to rubble. I wondered what had happened to the people.

After a while I walked on towards the city centre. At Lower Donegal Street I saw that though St Anne's cathedral had escaped the bombing, its neighbours had been razed. As I stood at the bottom of North Street I looked in silence at what remained of Waring Street, Bridge Street and High Street. Windowless husks of buildings and lone towering gable-ends stood eerily tranquil among the mounds of rubble, stacked high, waiting for removal. Huge fawn and white Clydesdale horses, coats shining with sweat, hauled cartloads of wooden crates towards the cargo boats anchored at Queen's Quay. People quietly crisscrossed the streets, intent on their own affairs. And clattering past, all unknowing of the trauma, were the trams.

For a time I stood halfway down High Street, making myself as inconspicuous as possible and jotted down a lot of little sketches, using the Albert Clock as a background. Further on I found that Arthur Street, Castle Street and part of the City Hall had been badly damaged and when I found myself back at the

High Street, 1941

corner of Donegall Street and Royal Avenue, I stopped again and made a few hasty sketches of the bombed buildings.

Even though I had heard it described over and over, I hadn't really expected the havoc in Belfast to have been so severe and the reality of it came as an immense shock. I thought of my father, just a few hundred yards from High Street, manning his machine-gun amid explosions, raging fires and flowing blood and as I stood there looking at the aftermath, I remembered his ironic description of the raid as 'a bit hairy'. If possible my respect and admiration for him rose even higher.

I left Belfast feeling very troubled. In the empty compartment of the train I did a few more drawings of what I had seen while my memory was still fresh. My box of watercolours still lay in Woodvale Avenue and I felt that I really needed it now, along with a quiet corner somewhere, to translate my sketches into colour. I couldn't see much chance of obtaining either.

When I got back to Greenisland ma and granny asked what I had been doing all morning and when I told them the only response I got was that I had missed lunch but could have a few sandwiches. The McKirgan side of my family were, in some ways, a very incurious lot but I usually didn't mind this as it meant that I could, and often did, disappear for hours on end without having to face endless questioning about what I had been doing. They probably knew anyway – drawing!

Carlisle Circus, 1941

Nearly four months passed before all the window panes in our house in Woodvale Avenue were replaced. The last to be glazed were the two attic rooms, one of which was my studio and ma heaved a sigh of relief at being able at last to clean her house from top to bottom again. As each floor of the house had the felt window coverings replaced with glass, she would take herself off to Belfast and systematically scrub and polish her way through the landing and rooms.

Tiny slivers of glass had pierced unlikely places and she sliced herself more than once in her ardent use of the scrubbing-brush or duster. When we moved house ma had bought a vacuum cleaner but now refused to use it for fear of ripping its rubber bag into pieces. Two paintings that had hung on her bedroom wall were peppered with cuts from flying glass and da had taken them down. She felt very peeved about this as one of them had been a wedding present.

My studio had miraculously survived without much damage as most of the glass from the shattered window had ended up in the passageway and street below. After a time ma began to fret about going home for good but da refused even to consider the idea, pointing out that if the Germans were to return it would most likely be during the dark nights of autumn. I think she must have accepted with some misgivings that this was probably true, for she let the subject drop.

The summer days passed slowly and I fell into the routine of weekly climbs up the slopes of Knockagh for supplies or forays on my cousin's bicycle to the hardware shop at Monkstown, sometimes even to Carrickfergus when a vital necessity ran out. My grandfather presided over a very flourishing garden of

vegetables, fruit trees and bushes and one day he asked if I would cycle to Ballyclare to fetch him some feed for his tomato plants. The opposition to this put up by granny and ma wasn't ordinary. According to them the roads were full of daft farmers driving willy-nilly, buses careening towards Belfast at break-neck speed and lost sheep meandering dangerously all over the place, just waiting to trip up unwary cyclists. Such a mission was suicidal they said and gave grandpa dog's abuse for even considering it.

However I bided my time and, at the first opportunity, I got out my cousin's bike and off I went. On the way I was overtaken by two cars and a tractor and on the return journey I pedalled past a laden donkey-cart as its driver wished me the time of day and was overtaken by one lorry. Not what you might call heavy traffic for a six mile journey. Having been accustomed to cycling all over Belfast, negotiating my way through trams, buses, trucks and horse-drawn carts, I really could not see what all the fuss was about. At teatime grandpa wore a straight face when they told him what I had done and later he furtively passed me a shilling.

Lack of money became a chronic problem and I was always skint. Luckily I didn't need much for there was nothing to spend it on; no picture houses on the doorstep, no tram fares, no water colours to buy and only a mangy ration of a quarter of sweets a fortnight to tempt me to part with the few pennies I did have. I always bought sweets; chocolate never lasted long enough.

My brain was already considerably exercised over how I was going to earn a living when the family eventually returned to Belfast. Two months ago my fifteenth birthday passed and I knew that sooner or later serious decisions about my future would have to be made.

Sammy Gourley (right) and friends

Sammy Gourley was a gnarled, pipe-smoking, hardened countryman who literally owned nothing but the clothes he stood up in and they had seen better days. He lived down the back lane, a few steps away from my grandparents' house. His home was a loft over a shed, the only access to which was a flight of wooden stairs.

Drawing from James's sketchbook, 1941

Sammy spent his days tending livestock and pottering around doing a variety of jobs for his boss, Jack Magee, who owned a few fair-sized fields around Greenisland. The Magees lived in a fine comfortable house which accommodated Sammy's humble abode in the farmyard. Sammy's year-round footwear consisted of one ancient pair of wellies, which in summertime must have killed him with sweat and discomfort, and a pair of faded brown shoes which sagged at the heel. He would discard the wellies and don the shoes only on a Saturday evening when he went to Carrickfergus for his weekly ration of Guinness.

One such Saturday evening, so the story went, Sammy staggered home a bit more the worse for wear than usual, wobbled his way up the wooden stairway and collapsed onto his rickety bed. Sometime during the night he awoke, drenched in sweat, to find an evil-faced apparition crouched over the end of his bed, slowly beckoning him with a long crooked finger. Poor Sammy was convinced that the devil was after him and he remained awake, shaking with terror, for the rest of the night. His fright was so complete that he gave up the drink for good or so he said.

Often as I sat drawing behind the hedge that bordered the back lane, Sammy would amble up, smoking like a train, plonk himself down beside me and give me a lecture on bovine and equine anatomy.

'That beast's ass is not square and boney enough. It's not a bloody horse you're drawing. And have a gander at its tits. They stick out between the back legs. Wait a minute and I'll throw a rope over its neck and haul it over so that you can get a better look.'

Deirdre, Magee's daughter, owned a striking brown and white pony and Sammy, after watching my struggles to capture its image on paper, would entice the pony near enough for me to have a good long look and then he

would stand with endless patience, slowly caressing the pony's mane and talking nonsense into its twitching ear until I had finished the drawing.

'Man, it's hard work standing here. I'll have a smoke and rest my ass for a wee minute.' And he would drop himself down with a grunt beside me. Then he would criticise my drawings, suggesting this and that and scold me for not having two eyes in my head. And his wee minute would stretch significantly when he swung into one of his yarns or passed on the gossip about who was up to what around Greenisland. Not that much ever happened anyway. Most of the time a graveyard silence hung over the place compared to the din I was accustomed to on the Shankill Road.

I enjoyed Sammy's craic and at times granny would accuse me of keeping him from his work, a feat which was not too difficult to achieve. Then in the next second she would say, 'Give the poor crater that pullover, it doesn't fit your grandpa any more. He hasn't a halfpenny to his name.'

Sammy acted as if he hadn't a care in the world. He was fed and housed free of charge and given a paltry wage that bought his weekly pints and tobacco and in all the years I knew him I never heard him express any dissatisfaction with his lot. His encyclopedic knowledge of the countryside and its animal life was fascinating. We were both master and pupil and his insistence that I get every animal's anatomical detail correct taught me a lot. Having a live model breathing down your neck as mistakes are pointed out makes for quick learning.

One morning around the end of July Sammy, accompanied by his collie dog, wandered up the lane. 'Do you fancy a job for a few days?' he asked me and leant sideways on a knobbed hawthorn stick.

'Any money in it?' I wanted to know.

'Ach there is, but it's damned hard going,' he answered.

'Well then, what's the job?'

'Pullin' flax,' he said.

Man with pipe, 1941

I had the distinct feeling from his tone that this job sounded like I should go climbing up Knockagh and forget it, especially when I remembered ma saying she had pulled flax in her young days and it was back-breaking labour. Sammy patiently explained that the flax was pulled into a bundle, roughly thirty inches in diameter, tied with rush straws and twelve bundles made a stook. Payment was by the stook and Sammy's estimate of a shilling per stook depended upon Jack Magee's generosity of spirit when he fixed the price.

'Where's the field?' I asked.

'Next to the station.'

'What, you mean that great big one?' I asked.

'Aye that's it.' Sammy sucked slowly on his briar pipe for a minute, then extricating it and aiming a great gob of spit at the grass verge, he explained that although Jack Magee was bringing in some experienced flax workers from Ballyclare, he needed some extra hands. His eyes searched the sky for signs of

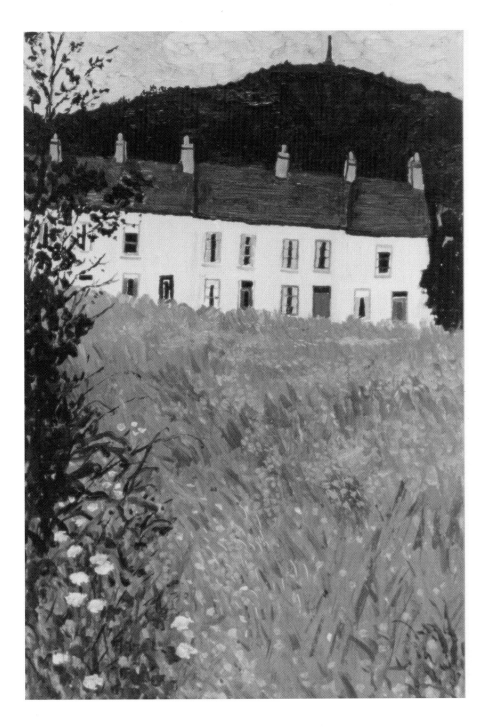

promising weather. 'Come down to the field tomorrow morning about nine o'clock and slap plenty of vaseline on your mitts,' and off he strolled down the lane.

The Rookery, Greenisland, 1949

Back home I told ma and granny about Sammy's job offer. They were less than impressed and told me how hard the work was even for someone with experience, much less a greenhorn like me. By the time they paused for breath I was almost wishing I hadn't been so ready to accept the offer, but the thought of having a few shillings in my pocket tipped the scales.

Next morning the obelisk on top of Knockagh peeped through a fine

summer mist that shrouded Anderson's farm and half the hillside, while out at sea the lough shimmered, still as a millpond. The weather was showing all the signs of a good stooking day.

When I arrived at the big field folk were already hard at work, chatting and laughing away to each other as they stooped and pulled rhythmically at the long golden flax stems. Piled into wigwams, some stooks were standing in a corner of the field as the labourers, both men and women, slowly fanned out, working their way over the field. I seemed to be the youngest person there. Sammy was wandering around acting as foreman, keeping a tally of the number of stooks built and he suggested that I start work at the far corner of the field. He advised me to work at my own speed and not to attempt to keep up with the others. I soon discovered what he meant as I watched one old boy of about sixty, stacking three stooks to my one as he kept going, effortlessly swinging backwards and forwards like a well oiled piston.

My own progress was also slowed considerably because I couldn't help stopping to look at the bent figures silhouetted against the backdrop of Cave Hill and Carnmoney Hill thinking what a good painting it would make. Sometimes I would catch them with Belfast Lough and County Down directly behind them and the scene was so breathtaking that it made me remember the reproductions of the paintings by the English Victorian artist Birket Foster that I had often thumbed through in one of my father's books. I decided that tomorrow my sketchbook would come with me.

At mid-morning we stopped for a tea break and lay sprawled on the ground. The sun had banished the early mist and now sparkled on the waters of the Lough. The boat-trains from Larne to Belfast passed through Greenisland every day but rarely stopped. When they thundered through the station, the

Sketch overlooking Belfast Lough, 1941

platform shuddered with shock and the stench of acrid smoke reached our nostrils in the field below. I could tell by the rapid chug of the engine when I heard it in the distance what kind of train was coming. On the first day, as the boat-train roared past, it blew two powerful blasts of its whistle and the driver leant out and waved at us from the cab. One of the Ballyclare men suddenly leapt to his feet and waved back.

'The driver's yin o' me brothers,' he said grinning.

On hearing this we all waved as well.

When we stopped for lunch Sammy wandered up to me as I ate my sandwiches.

'You stickin' the pace alright?' he asked with a grin, pulling out his pipe for a smoke.

'I am but I can't keep up with this lot,' I said glumly. I had given up in disgust counting their stooks against mine.

By finishing time my hands were pink, covered in tiny nicks and my back was stiff, although not as bad as I expected it to be. At home, over tea, I was grilled about the day's events. How many stooks had I pulled? Was Jack Magee there? What was Sammy doing? Who else was there? I had barely time to eat as the barrage of questions continued.

A week of glorious weather burned my face the colour of a beacon and by the Saturday morning we had finally cleared the field of flax. I couldn't have believed it possible that in less than a week we would have filled the enormous field with our stooks. In spite of all the hard slogging I had enjoyed myself immensely. I loved the Ballyclare folks' craic even though at times the speech

was so broad and fast that I barely understood what they were saying. I had also managed to find time to do some drawings and I eagerly looked forward to making paintings from them when I got the chance.

At the end of the last day Jack Magee arrived carrying a wooden box. He bunched us together in the field, called out our names and handed us our wages from his portable bank. I got thirty-eight shillings which was a fortune to me and he told me with a grin as he held it out to me, 'Don't let your granny get the hold of that.'

Altogether I had pulled thirty-eight stooks; a piddling number when set alongside the ninety-five achieved by the hardest grafter in the field. He had toiled ceaselessly as if a demon was chasing him and I never knew how he managed to stand upright at the end of each day. As well as this he cycled every day from Hydepark to Greenisland and back, which was no mean distance. Contrary to granny's dire predictions I had suffered no more than a slight backache every night and after a good sleep I was fine by the next morning. But even if my back had murdered me I would never have admitted it.

I had promised myself that if ever I accumulated enough cash I would buy myself a bicycle and da had said he could get me a good second-hand one. I explained to ma what I wanted to do with my hard-earned money and for once she raised no objections.

Being a message boy and cycling all over Belfast had given me a taste for travelling further afield, especially with the Scouts at weekends and I reckoned that with a bike I would certainly save money on tram and even train fares.

That evening, while we all sat around the tea table, I asked granny if she would mind leaving the back door unlocked at bedtime as I might be a little late arriving home.

'Why?' asked ma suspiciously and looked sideways at me.

'I'm going to a dance!'

'What?' she squeaked.

'Ah,' chirped Aunt May. 'He's found a young lady friend down at the flax field. Is she nice? What's her name?'

God, I thought, I've put my foot in it now. Really, the last thing I needed was my daft Aunt May pestering the living daylights out of me. 'Never you mind who I'm going with,' I said, feeling my face get hotter by the second.

'Good for you,' said grandpa, rising from the table.

Granny gave him a withering look as he took himself out to the garden. These days grandpa was hemmed in by bossy females and when the pressure became too much he would vanish to his greenhouse for a bit of peace and quiet. There he would sit puffing his pipe, watching his tomatoes ripen.

After he left, granny began reminiscing about her young days. She chuntered on about how when the flax fields were cleared, they always held a dance in Finlay's big barn at Crannagh Hill.

'Ah,' she mused, giving me a knowing look, 'many's a quare fella I met there.'

That was enough for me. I didn't like the way this conversation was going so I upped and chased after grandpa and discovered him and Sammy, prostrate behind the hedge in the back lane, their hats pulled down over their faces to keep off the slanting sun, arguing about the war situation. As I flung myself down beside them the bright sun glinted off the wildflowers, grasshoppers chirped a tune and bulbous queen bees dipped, hovered and threaded their way through the tall grass which was now almost ready for harvesting.

'Here comes the worker,' said Sammy.

'Right, that's enough,' I laughed. 'If Jack's looking for workers next year, for-get about me. It's hard going, like you said Sammy.'

'Ach, it's a good job you're not retting the flax as well,' he answered.

Grandpa screwed up his nose. 'I don't want to hear anymore about flax. I've seen enough of it to last me a lifetime.'

'You're right,' responded Sammy. 'Stick to your paintbrushes.'

As I sprawled dozing in the warm sun, I couldn't help wondering how I had

Lundy's ice cream shop, 1949

ever allowed myself to be talked into going to tonight's hooley. I had never been inside a dance hall in my life and couldn't jig a single step but I had been assured that this was not a problem and that the girls would teach me. All summer long, in the company of a group of youngsters of my own age, I had climbed Knockagh, scrambled over the lough foreshore, played tennis at Fauroran House and walked to Lundy's shop at Trooperslane for the only available ice cream in the district. The others were all natives and I was the only outsider but I soon made friends and was happy enough.

Dances were a rare event at the Knockagh Road Hall. The girls were itching to go and wanted the boys to partner them. Finally everyone became pinned down except me. All along I had baulked at the idea, insisting that I couldn't dance and harboured no desire to learn. But one girl was left in limbo without a partner and the others made such a fuss, accusing me of spoiling her evening's fun that, in the end, I very reluctantly relented and agreed to go. I had regretted the promise ever since and was still trying to come up with a legitimate excuse to get out of it. Nothing came to mind.

Hats pulled low over their brows to shield them from the sun, grandpa and Sammy were still at loggerheads over the war situation when I got up and announced that I was off home to take a bath. Enjoying a bath in granny's house depended solely on how much time would elapse between sinking into the water and someone rattling a frantic tattoo on the bathroom door.

'A bath?' echoed Sammy incredulously, the war momentarily forgotten. 'Can't even remember the last time I had one!'

I knew he wasn't kidding.

Later that evening, as eight of us walked the steep Knockagh Road, we could hear the jingle of music floating over the calm evening air long before the dance hall came into view. Folks of all ages, seemingly from about fifteen to eighty, were squeezed into the modestly sized hall and whoops of laughter and accordion music vibrated around the walls to the stomping of feet as the dancers whirled each other round. By the time we had hung up our coats, the music had temporarily wound down and everyone had collapsed breathlessly onto the long row of chairs lining each side of the hall. What misgivings I had suffered about the prospect of making an eejit of myself on the dance floor soon vanished as I watched other nervous shufflers treading on their partner's toes and jostling the other dancers.

I was pulled reluctantly to my feet when the fiddler and two accordion players struck up a waltz. My partner slowly demonstrated the dance steps and I was told to relax, loosen up and not move like a bag of spuds on legs. After we had sailed past the musicians a dozen times, the steps gradually became less of a mystery to me and only once did we do a bouncer off another couple. An hour later the waltz seemed like child's play compared to the mad whirling jigs I had to endure, as I was hauled up and down the length of the hall, completely lost and disorientated by the mass of bodies sweeping by. By the time the musicians decided to take a break I was suffering from the head staggers and was extremely relieved to plonk myself into the nearest chair where I sat watching the movement of men in and out of the hall.

I asked the old boy resting beside me if there was a toilet outside.

'No, son. Are you lookin' for one? It's at the end of the hall.'

'No, I just wondered why those men keep going outside,' I answered, nodding towards the door. I had noticed that after each group returned they seemed to be a lot happier and more animated than before they went.

The old fellow leant towards me, gave a slow wink of his eye and whispered, 'Keep it to yourself son, but there's a crate of Guinness outside. No drinkin's allowed in the hall.'

Close to eleven o'clock when the dance was due to end I could still sort of perform only one dance, the waltz. I had spent the entire evening clumping around beside my partner but mastering the repertoire of steps needed for other dances just seemed to addle my brain and I gave up even trying. Some of the other lads didn't fare much better and we had a good laugh at each other's discomfiture.

At one point in the evening the music suddenly died halfway through a dance and everyone gazed expectantly at the musicians as we waited bemusedly for an explanation. It transpired that one of the ladies had managed to lose a brooch and we were asked to stand still and have a good look at the floor

around our feet. Amid a shuffling of bodies and a murmur of voices, we each examined the bit of floor nearest to us. Suddenly the door was thrown open to admit four figures swaying slightly on their feet and blinking their eyes against the light.

'What's wrang wi' ye all? Is the dance over? What are ye all stannin' like statues luckin' at the floor for?' asked one of them.

'Archie, will ye shut yer gob,' shouted a buxom woman, who had been standing beside me.

Archie focused with some difficulty on the ample figure of his furiously embarrassed wife as he ambled boozily towards her, still demanding to know why the music had stopped.

'I thought I told ye not to touch any drink the night!' she hissed.

Turning her back on him she moved one plump elbow with lightning speed and buried it smack in his beer gut. A whoosh of expelling air left him round-eyed and purpled-faced and he doubled up, facing my partner and I.

God, I thought, he's going to spew booze all over us. However, his wife grabbed his collar and propelled him crabwise towards the door, where his three companions still stood open mouthed.

'Out,' she yelled, fixing them with a menacing eye. 'And take him wi' ye.'

The door shuddered on its hinges as she slammed it behind them. A wave of laughter went roaring round the hall.

Soon after this diverting drama the lady's brooch was discovered beneath a chair and the musicians struck up again and not long afterwards a last waltz brought the evening to an end. The audience clapped and whistled their appreciation of the band's performance and my companions and I retrieved our coats and slowly made our way out into a stunningly moonlit night. The high hedges cast deep blue shadows as we linked arms and spread ourselves out across the twisting downhill road, homeward bound. Someone started to sing and soon we all loosened our lungs and bellowed out not a very tuneful "Bless Them All . . . " We went from one song to another all the way home to Greenisland, where we parted company as we each went to our various homes.

My partner and I stopped by the shrubbery at the drive of her house and I leant against the wide gatepost, closed my eyes briefly and was conscious that what with gathering flax all week and then my antics on the dance floor tonight, my back was starting to ache. Suddenly I felt two arms encircle my neck and my partner gave me a long kiss.

'I really enjoyed the dance,' she whispered. 'Thanks for coming with me.'

And before I could say a word she ran off up the garden path to the house, turning to wave before she gently closed the front door. For seconds I stood in a complete daze then slowly shook my head and walked away. The day had been a terrific one. For once I had real money in my pocket, I had gone to my first dance, learnt to waltz and had been kissed for the first time.

One morning about a week later I returned from a trip to Anderson's farm to discover that a postcard addressed to me with a Portrush postmark had flipped through granny's letter box. A cryptic message of just three words was written on it.

'From . . . Guess Who?'

Of course the entire family had read it before me. Aunt May gave me a dog's life over it. Granny embarrassed the daylights out of me by hinting at all sorts of romantic goings-on and later that evening my uncles and cousin, after a great deal of leg-pulling, told me that I was a real dark horse. I refused to answer any of their questions and at last they got bored and let the subject drop.

I had a good idea who had written the card.

Anderson's farm, 1947

Jordanstown station,
1945

5

Jimmy Duff, the porter at Greenisland station, swept a mixture of dead leaves and litter along the station subway and zigzagged the small mound onto a shovel. He stood for a long second, bucket and brush in one one hand, and watched us as we sprawled on the concrete steps leading up to the platform. Jimmy kept a scrupulously tidy station and was prone to fixing potential rubbish droppers with a baleful eye. On this occasion, having satisfied himself that we were merely idling our time away, he contented himself by remarking that it was lucky for some who had nothing to do all day but make his station look untidy. We just smiled at him.

Actually, we were engrossed in discussing the notion we had come up with of going fishing off the local foreshore at a spot commonly called The Gut. We had decided to build our own boat from scraps of wood. Not one of us had a clue as to how to begin. I had chalked out the rough shape of a boat on the ground and Ed Clarke and Jim O'Neill sat inside it, one behind the other, while I measured the proportions by drawing chalk lines around them to indicate its length and where the seats and rowlock should be. For the last hour we had rattled our brains over the finer points of its construction, not the least of which was how to keep it afloat.

A keel was temporarily dismissed because we couldn't think of a method strong enough to attach it to the bottom. Eventually from our deliberations a

flat-bottomed design emerged which had a wedged-shaped front, overlapping side planking and two seats. It had four corner posts, a bow and we planned to caulk all the seams with strands of tarred rope and brush generous dollops of hot tar over the flat bottom. Even before the first plank had been sawn we had named it the *Sea Hawk*, after the film starring Errol Flynn.

Over the next few days the three of us began the task of cadging and bullying folk into handing over timber scraps from their garden sheds and out houses. Further down Station Road a half-built house sat amidst a heap of excavated soil and we enviously eyed the timber scattered around the site.

'I wish we could get our hands on some of that.' said Ed.

'I know what you're thinking,' replied Jim. 'But you can count me out. I'm not going on any moonlit raids.'

Ed and I looked at each other weighing up the possibilities but said nothing.

Faunoran House, a large Victorian pile, sat at the end of a long curved driveway, surrounded by trees of all shapes and sizes. It had a tennis court, a walled garden and wide open lawns sprinkled with shrubbery. Jim's father was chauffeur and groom to the Wilson family who owned the big house and they lived in the gatehouse beside the front entrance. We decided to build our boat in Jim's back garden. When later I told ma what we were up to, she was appalled at the very thought of it. She pointed out in unflattering parlance our lack of skills and experience as boat builders and finished off with a few acid comments on the paucity of our talent as

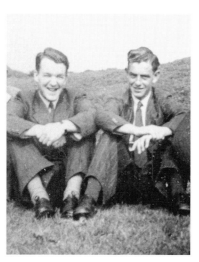

Jim O'Neill and Ed Clarke

offshore fishermen. Granny was loudly convinced that we would drown ourselves but grandpa offered to help us with the woodwork.

After about a week we had gathered enough timber to make the bottom, which measured eight feet from stern to bow. We had only one good ripsaw and though our sawn edges couldn't exactly be described as professional we were improving by the day. The *Sea Hawk* slowly progressed and word soon spread about our enterprise. Another lad called Desmond Beattie turned up with a hammer and happily set to banging in nails. Casual sightseers would amble up, offering all manner of advice, many of them cheerfully predicting that our boat would nosedive to the bottom or capsize before we dipped an oar and send us all to a watery grave. One old sea dog cast a very critical eye over our joinery efforts, scrutinised the design and told us that when the time came we should climb aboard from the rocks or, if in open water, only from the stern. 'It'll float if you can keep the tide out,' was his final remark, which made our our chests puff with pride.

Nails and screws vanished by the dozen and we scrounged shelf brackets to stiffen the sides and stern panel and enough rope to caulk the *Titanic*. We carefully filled every crack with roped strands, built a roaring fire, boiled up tar and brushed it, bubbling into every seam, hopefully making our craft watertight.

Someone presented us with a tin of glossy dark brown paint and I painted

the boat inside and out and lettered *Sea Hawk* in broad white strokes across the prow.

We were mighty proud of our achievement and invited everyone we knew to view it before the launch, at which time we were faced with the problem of actually getting it to the sea which was nearly a mile away, though luckily downhill.

We thought of asking for help from one old boy who owned a donkey and cart but he lived so far away that we thought the poor donkey would be running out of steam before it even arrived at the O'Neill's house. We hesitated to ask anyone with a car because of the meagre wartime petrol allowance. The solution came unexpectedly when we were offered a pair of huge wheels from an invalid chair. Nearly a day was spent in fashioning an axle and platform wide enough to support the boat and when this was attached to the wheels, the whole contrivance ran as smooth as butter.

Launch day was heralded by a hazy sun breaking through the morning mist, warming the air, and the prospect of finally seeing our boat afloat had us excited beyond words. As we rolled effortlessly down Station Road, an old boy out for a dander stopped and stared, then guldered at us. 'What's that contraption you have?' Without giving us time to answer he went on, 'Jesus, it's a boat! Surely to God you're not going to sail in that? You'd better say your prayers if you are!'

'Oul eejit,' muttered Ed under his breath as we trundled on.

The full tide lapped gently over pebbles and sand and the water shone smoothly, reaching far out into the misty lough. In the distance, just off Bangor Bay, could be seen the hazy outlines of an armada of cargo boats at anchor. We hauled off our shoes, rolled high our trouser legs and gently manhandled the *Sea Hawk* into the water. Anxious minutes were spent searching for leaks and we heaved a collective sigh of relief when not even a trickle appeared. It floated in eighteen inches of water and Ed climbed over the stern while Jim and I held it steady.

Anxiously we watched him manoeuvre himself onto a seat and fit the homemade oars into the rowlocks. The oars sank and gently he put a thrust upon them and slowly the *Sea Hawk* edged through the water, leaving a tiny wake of bubbles behind.

We broke into hoots of laughter and cheers of relief. Each of us had a go, gingerly testing the oars for a response in manoeuvring our way out to the reef and back.

The morning flew by in a flash. We kept a constant lookout for leaks but none appeared and as we recalled all the jibes and predictions of watery graves we had endured, we stuck our thumbs in the air, beaming with the pride of achievement. Before going home we beached the *Sea Hawk* far up behind some rocks.

That evening, gathered around the tea table, I recounted to the family the

whole story of the day's events. I expected a tirade from ma and granny but for once they were mute and grandpa just sat there smiling broadly. The following day I presented granny with two fine mackerel.

One day I coaxed one of the local girls, Iris Bell, into taking a little trip out to the reef. The sea was calm except for the odd frothy wave surfacing here and there but, just as I swung the boat broadside on to return, I noticed the wake of a large cargo ship swirling steadily towards us. It reared the boat up onto its crest and as we sank sideways into the trough, sea water splashed over our legs. Iris wore only short ankle socks and she was soaked.

She screamed blue murder, which slightly unnerved me, and I had just managed to turn the boat around again when the stern rose upwards on a second wave. We sank again, bow downwards, and Iris gripped her seat, her eyes wide with with terror. More by luck than skill I managed to keep the bow steady while praying that Iris wouldn't do anything daft such as trying to stand up but would just continue to sit there, yelping like a maniac. As we drew close to the beach, a couple of friends waded out and dragged the *Sea Hawk* onto a patch of sand. Iris leapt out like a gazelle, soaked, scared and yelling that she was never again going to get into a boat.

For my friends and me, the pleasure we had from building and sailing our boat marked our last carefree summer before our working lives began. In January 1941 I began to keep a diary and a short entry in late October states: '*Sea Hawk* stolen or swept out to sea.' It was never seen again

The last few nights of autumn were dismal and twilight seemed to drop ever earlier. A drizzly mist hung over Knockagh, shrouding it from morning until evening and engulfing Jim Anderson's farm. I spent most of those days in granny's parlour, crouching on the floor, a plywood drawing board resting on my knees and surrounded by the more promising of my sketches which I had redrawn for future use as watercolours.

Since the Blitz of six months ago I had enjoyed most of my sojourn in

Greenisland, but recently time had begun to drag and I wished myself more than ever back in my studio. I noticed that ma was also showing signs of frustration. My baby sister would sometimes bawl for half the night, keeping everyone in the house awake and ma's longing for her own space was becoming more evident. Then I overheard an exchange between her and Granny.

'That wee fella needs to get an apprenticeship. He'll soon be sixteen and Jimmy should be doing something about it! Sitting there all day drawing pictures isn't going to feed him.'

I had, of course, been thinking of what I was going to do with my life and what sort of job I would like. I was interested in woodworking and would have readily accepted an apprenticeship as a pattern maker or a carpenter. Deep in my boots though I had only ever harboured one real ambition. I wanted to be an artist. However, even the very mention of this had the effect of causing my elders to raise their eyes skywards in exasperation.

Herdsman's farm, 1942

On the sloping road beside granny's blue painted front gate, da's Ford 8 trundled to a halt, and the engine coughed into silence. October was half over and we were were going home to Belfast at last. Ma and I had heaped our belongings in the hall, ready to load into the car, and she was feeling very relieved. When finally packed solid with baggage and passengers, da's pride and joy was almost resting on flat tyres. With a critical eye he walked slowly around it, while grandpa stood by and scratched his head. I offered to give up my seat and go home by train but ma wouldn't hear of it and told da to get a move on. When, at last, the car turned slowly into Woodvale Avenue ma gave a great sigh, and whether it was of relief at our safe arrival or just the sight of her own home I couldn't tell.

Our belongings were scarcely unloaded when da told me there was something that might interest me in the yard. When I went outside I found the shed door lying half open and propped against the bench was a glistening chrome and black bicycle. A BSA medallion sat proudly on the handlebar stem; it had twenty-six inch wheels, a wide comfortable leather saddle and, thank God, no three speed gears. I loathed them. To me they were a hindrance not an asset.

Carefully manoeuvring it through the back yard door, I rode off, up and

down the road a few times to test the brakes and its balance and declared it the smoothest running cycle I had ever sat upon. It belied its heavy framework and was surprisingly easy to pedal uphill and I reckoned da had spent my flax pulling money handsomely.

During my time as a messenger boy I had always intended to visit Donegall Road, Falls Road and Oldpark libraries in an effort to find new art books but I seemed never to have enough time. Now, with transport again and no time shackles, the libraries would be accessible and had winter not loomed I would have ventured further afield into the country-side, in search of inspiration for paintings. Not that I was short of ideas; the studio held dozens of drawings but I seemed to be constantly looking for material and I was plagued by my inability to achieve the standard I set for myself. With an apprenticeship looming I wanted to make the best possible use of the leisure time left to me.

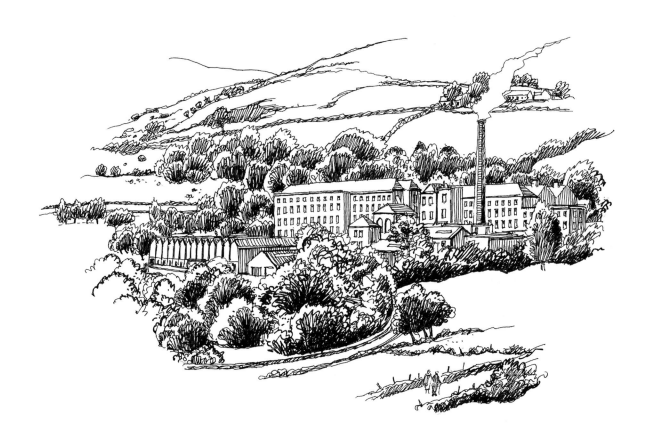

Drawing from sketchbook, 1947

In the springtime, da was rarely to be found around the house. Any spare time he had was spent on his allotment at Ligoniel. There he grew green vegetables and potatoes, all planted in neat rigs and beds, and each autumn he would harvest a bumper crop that fed us for months.

Ligoniel mill To assist the war effort the government encouraged everyone to grow their

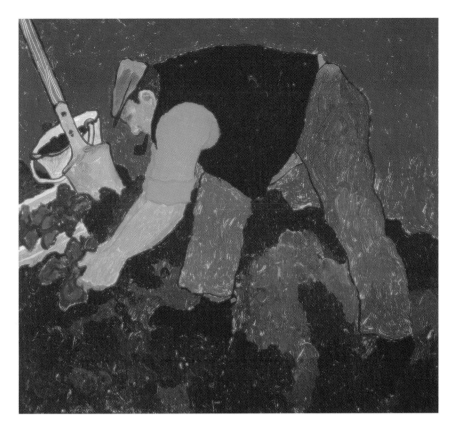

own food and, listening to da's talk of some of the would-be gardeners' prob-
lems, it was clear that many of them hardly knew one end of a spade from the
other. One evening, after another long stint at the allotment, he arrived home
late for tea. After listening patiently to ma's grumblings about his spoiled meal,
he announced casually that he had arranged for me to serve an apprenticeship
as a motor mechanic at Coulter's garage on the Cliftonville Road.

Man gardening,
1948

For a few moments a hush surrounded the table while I grappled with the
news and its implications. Ma broke the silence.

'What's his pay and hours?'

'For the first year, five shillings and sixpence a week, rising every year for the
next five. Hours are 8.30 am to 6 pm with an hour for lunch and a week off
in the summer,' declared da looking at me.

'Well,' he asked, 'what do you think?'

'Yeah, it sounds alright,' I looked at da with a half grin. 'I'll learn how to
drive and run you all down to granny's at the weekends in your Ford.'

Just for a second, a look of apprehension spread over da's face and I knew he
had never considered the possibility of me behind the wheel of his pride and
joy.

'No, you won't,' said ma briskly. 'We've enough reckless maniacs already in
this family.'

Da's persistent habit of crawling along straight bits of road and then tearing
at speed around corners raised her bile.

I had long had a feeling that decisions about my future were being taken that
involved my Uncle Jim. He had trained as a motor mechanic and a few years

before the outbreak of war, had started a garage business in a large, former coach shed in Greenisland's station square. A petrol pump had been installed and he seemed to be doing steady business, repairing cars and dealing in second-hand vehicles. But, when the war started, trade plummeted and he was forced to abandon his livelihood for the duration. Now I recalled the conversation I had overheard between ma and granny and I wondered if they hoped that I would eventually go to work for Uncle Jim after the war.

Later, in the studio, I felt relief that at last my future had been settled, even if only to enjoy once again the benefits of a weekly pay packet. What little money I had earned cutting hedges and mowing lawns at Greenisland had dissipated weeks ago and lately I had become completely skint, surviving on the half-crown da gave me every month for pocket money. Most of that went on art materials.

A fortnight later, feeling very conspicuous in a brand new pair of brown overalls, I set off on my bike for Coulter's. After three months working in the stores department I had gained a fair knowledge of Ford vehicle parts and could at least recognise a tappet from a crankshaft. Then everything changed when the foreman stopped me in the forecourt one morning and told me that I was to commence work the following week as an apprentice alongside a mechanic called Sam Holden.

Sam had a good reputation as a mechanic and was something of a dandy in his spotless overalls, covering fresh white shirts complemented by a variety of tartan ties. He was also a ladies' man. He could charm female customers off their perches with smiles and chat and when he delivered their repaired cars onto the forecourt, he would gallantly hold open the door for them.

'Smashing pair of legs that one!' he would afterwards remark.

Sam was single and he rented a room from an old dear whose house fronted the Cavehill Road. She doted on him and turned a blind eye to the comings and goings of his numerous girl friends. He hailed from a townland in Fermanagh and he spoke with the soft lilting accent of that area. Every two months he would travel home by bus for the weekend but couldn't wait to return to Belfast saying that he was bored in the sticks, which wasn't surprising given the breadth of his social life in Belfast. From our first day together Sam and I slid into an easy partnership which lasted for four years.

In Coulter's large, two-storied workshop, accidental injuries were very common and were treated by bandages and plasters kept in the office first-aid box. One morning, a scream rang through the entire building, making the hair at the back of my neck stand on end. One of the mechanics had had his foot squashed by the wheel of a tractor and he lay pale and unconscious, with blood oozing through his boot, as he was gently brought to ground level in the hoist and then eased into a van and rushed to the nearby Mater hospital. This

incident left everyone feeling uneasy and there was much discussion about the lack of safety regulations.

My first month at work unsettled me and I did little painting or drawing during this time and used to spend the long summer evenings mooching around in Woodvale Park, watching the bowlers, cricketers or quoits players. However, eventually I got to thinking of all the Greenisland ink sketches lying untouched in the studio, just waiting to be turned into watercolours and before long the excitement of painting gripped me again.

Sometimes on Saturdays I shopped for art materials but often supplies were hard to come by and if I needed a particular colour I regularly had to visit all three Belfast art shops in an attempt to find it, and then not always successfully. One morning when I was in Rodman's, a well-dressed man, looking not in the least like a down at heel artist, asked for 300lb watercolour sheets. Instantly my ears tuned in and I sidled nearer the counter, eager to see these watercolour sheets. I always painted on thin watercolour paper pads which had a slightly off-white tone due to wartime restrictions on quality paper.

The assistant returned with huge sheets of pure white stiff card, wrapped them up for the customer and, when I heard the price, my ears nearly dropped off. When he had gone I asked the assistant, who was used to seeing me in the shop, why the paper was so thick, heavy and expensive. She explained that it was handmade and didn't need stretching and that it was extremely difficult to come by. I stared at her and it was obvious from the look on my face that she guessed I hadn't a clue what she meant. Then she told me that thin watercolour paper buckles when washes are applied to it, and that before use it should be soaked in water, laid flat and then stuck down with gummed paper so that when it's dry, washes would float easily and the paper would not buckle. She also explained that boards came in measured weights of thickness, the heaviest being 400lbs, but that even if I had the money to buy them she couldn't sell them to me because their supplies were so limited they were reserved for professional artists.

Herdsman's farm, 1945

'Did you ever hear of Frank McKelvey?' she asked.

I nodded enthusiastically

'Well, that was him just now!'

I bought a roll of gummed paper and rushed home to tell ma I had seen Frank McKelvey and to soak four watercolour pages in the bath. I gummed them down and next day I achieved my best watercolours ever. My five-minute encounter with Frank McKelvey had opened a door for me. For years

I had been plagued by coloured blobs on my watercolours which dried with hard edges that were impossible to erase. My feeling of gratitude to the lady assistant in Rodman's for her advice was unbounded.

What knowledge of art and artists I possessed originated from books. The art section of one in particular, called 'Pictorial Knowledge', which da had bought when I was about six years old, became my bible. From it I learnt to recognise the work of British and continental artists long before I could pronounce their names. Constant drawing and copying filled my early years in attempts to improve my technique but, as I grew older, it dawned on me that I was only reproducing other people's conceptions. I was about fourteen when the real struggle began to become an artist in my own right. I tended to copy less and less and began gradually to work my own drawings into colour.

I was six months into my job on a cold dry October morning with just a hint of sunshine glinting over a forecourt crammed with trucks and cars ready for servicing.

Sam's head was buried beneath the bonnet of a Ford 8, loosening radiator bolts and hosepipe fittings, while I waited patiently below in the pit with a bucket ready to catch the water from the radiator. The pit lay alongside the entrance gates and when I suddenly looked up my jaw dropped open in astonishment. Silhouetted against the pale sunlight stood a figure with hands propped idly on hips, peering into the workshop.

He stood at least six feet tall but what emphasised his gangling height even

more was a huge wide-brimmed stetson, pulled low to one side on his forehead. He wore a broad-collared, brown sheepskin flying jacket and his fawn trousers were tucked inside a pair of high-heeled ornamented cowboy boots, which stretched halfway up his calves. All that was missing were the clanking spurs and six guns on each hip. I gaped in amazement and finally croaked up to Sam, who was still under the bonnet.

'Sam, quick, look what's standing at the gate.' I heard a scuffle as Sam extricated himself from under the bonnet.

'Jesus Christ, the Texas Rangers have arrived!' he exclaimed.

I watched as Sam walked towards the cowboy and engaged him in conversation. The animated gestures and banter went on for at least ten minutes until Sam ushered the exotic stranger to the ground floor office where

another conversation was struck up with Sally Langtry, one of the clerks. By this time, I had hauled myself out of the pit for a better view of the goings-on.

After a time Sam and the cowboy emerged from the office where a goggle-eyed huddle of girl clerks had materialised and made their way through the workshop to the stores department, where they stayed for a short time before eventually returning to the entrance. Mechanics hovered behind trucks and cars as they passed, all eyes following the progress of the cowboy who seemed to be completely unfazed by the attention he was getting. He might have been a film star given the sea of admiration surrounding him and I had to admit that with his lean tanned face and slow alien drawl, it was little wonder the girls were captivated.

At the gate Sam shook hands, clapped the cowboy's shoulder goodbye and watched him as he sauntered towards the jeep, a box full of spare parts beneath his arm. He hopped aboard and then turned to wave before speeding off. Sam's face split into a broad grin as he told us about the American who was an airman based at Langford Lodge. His name was Joshua O'Keefe and he came from Tennessee. Apparently he told Sam that his commanding officer wanted to organise a barn dance for the following Saturday to cheer his men up a bit but since they had only just arrived from the States, they didn't know any of the locals and Sam, with Sally's help, had obligingly offered to find some girls willing to go to the dance.

'Of course, as the organiser, I'm invited too,' he said, grinning happily.

On the Monday morning after the hooley, Sam arrived at work still looking bleary-eyed and the girls mooned around the office, endlessly discussing all the evening's events. As Sam and I toiled over an engine, loosening the chassis bolts, he chattered on about the dance. Apparently there had been unbelievable supplies of food, beer and soft drinks. The band was fantastic and Sam was much impressed by the dancing prowess of the Americans, especially the coloured men. He said his legs were hardly fit to support him after all the dancing he had done. The commanding officer had made a speech thanking everyone for coming and promising a repeat performance. The evening had drawn to a close with a rendering of 'Danny Boy' to the accompaniment of cheers and whistles of delight. 'Best night ever,' was Sam's verdict.

About ten days later Joshua turned up again, this time in his air force uniform and peaked cap. He told us his squadron would be going to England in a few weeks time and that they were on navigation practice flying. Rookies preparing for long distance bombing raids was how he put it. Like Sam, he was unmarried and Sam offered to introduce him and his crew to the lesser known delights of Belfast, which translated meant mostly pubs and girls.

Sam's easy manner sat well with the Americans and they would ply him with presents for himself and his friends. After their forays Sam often produced bars of American chocolate for me and his landlady.

Meanwhile, as Christmas approached, ma cast an appreciative eye on my latest watercolours of Anderson's farm and wanted to give granny one as a Christmas present. She had never asked me for a painting before and if she felt prepared to throw money out on framing one I thought she must be really impressed. I was dead chuffed. I asked one of the apprentice joiners at Coulter's if he would make me some frames and when finally one morning I produced the paintings all mounted and ready for framing, Sam looked at them in astonishment.

'Did you really paint these?' he asked and promptly offered to buy one from me for seven and sixpence to give to his mother for Christmas.

By the end of the day I had sold two other paintings and had accepted orders for three more. I was bursting with pride and some surprise at the thought that people were actually prepared to pay real money for my work and to hang it on their walls.

The extra orders, however, presented me with a problem. Although I had paintings lying around in the studio I was not happy with their quality and I knew that I would have to produce some more in a very short time. I had never found it easy to paint by artificial light as I found that it changed the colours completely. Now, with a little over a week to go until Christmas and only limited opportunity at the weekend in which to paint in daylight, I was feeling pressurised.

Then ma decided that on one of my precious Saturdays she wanted me to go to Greenisland to get fresh eggs and butter for her Christmas baking. She was in a bad mood and although I argued and explained to her why I couldn't go on Saturday morning, she was insistent. In the end I told her that, as I could earn more money from the paintings than I could at work, I would take the Friday off and go to Greenisland then. She was not happy at this but I was determined and so on the Friday I set off for Greenisland, returning later laden with butter, eggs and home-made jam. Over that weekend I completed four paintings and on Monday morning Sam bought the extra one at half price as a present for Joshua. After I had paid the joiner for making the frames I had

Entrance to Anderson's farm, 1947

three pounds left for myself and suddenly painting assumed an even greater importance in my life.

A few days later Joshua sauntered into the workshop, his stetson low over his

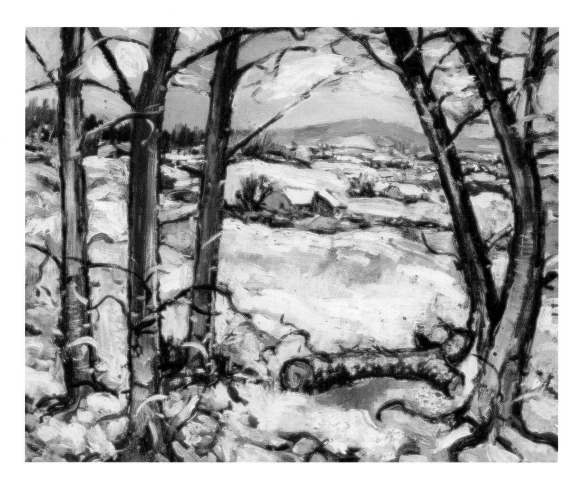

eyes, with news that another dance was planned for the New Year. Sam presented him with the painting and, beaming from ear to ear, Joshua told me how delighted his folks would be to have it. As for me, I was tickled pink at the thought that of one of my paintings would soon be hanging in Tennessee, USA. Then, after wishing us all a Merry Christmas, he tilted back his hat, shook hands all round and with a wave to the girls in the office he was gone. We never saw or heard from him again and surmised that his squadron had suddenly been posted to England. We often thought of him and wondered if he had survived the bombing raids over Germany.

Snow scene, 1946

For some time I had been eager to paint in oils and early one morning I hesitantly began to daub a brush, thick with oil paint, onto a canvas board. I knew nothing of the techniques involved but there was only one way to find out.

Oils, I soon discovered, were easier to control than watercolours but they were messy and stank the studio of linseed oil and turps. I didn't mind, it just felt wonderful to be able to paint over mistakes and try again, unlike watercolours where, after hours of labour, one serious mistake could ruin a whole painting. I found myself in the grip of a burst of creative energy and after painting every evening for a week I had produced half a dozen small oils which turned out better than I expected. Flushed with success, I attempted a self-portrait. It failed miserably. However, failures were nothing new and had

Self-portrait in pencil,
1943, aged 17

to be accepted. But, when asked by the Scoutmaster to paint a banner for a county flag competition for which the troop had entered, my oil painting experience proved useful. The banner, when completed, measured ten feet by two and won first prize. I received a plaster bust of Baden-Powell for my efforts.

In 1943 our summer camp was to be held at Portstewart and in early May six of us excitedly set off by bike to check out the campsite. We chose a tortuous route because we knew that a return trip would be impossible to achieve in one day so we followed the coast road and slept overnight at Carnlough Youth Hostel. We rose early to a beautifully clear sky, breakfasted well and set off up and over the Antrim plateau to Ballycastle and then hugged the coastline to Portstewart. Once there we admired our prospective campsite overlooking the strand and the River Bann and, after resting our bones for an hour and stuffing ourselves with food, we began the long journey home. Bone weary and knackered we reached the outskirts of Glengormley at nine o'clock that evening. The blackout had descended and half of us were minus headlights

which forced us to walk the remaining distance home. We arrived at eleven o'clock in pitch darkness, only to discover our parents had been running frantic with worry about us. Ma lost the bap entirely and read the riot act but I was completely exhausted and past caring or even listening.

Next morning my backside felt really miserable. I could just about sit on the bicycle and had to keep hopping from one cheek to the other, all the way to Coulter's.

Sam, with a huge grin on his mug, was vastly amused as he watched me walk about bow-legged and told me I looked like I had a turd in my drawers. The Scoutmaster later estimated our ride from Carnlough to Portstewart and back home to Belfast to be one hundred and ten miles. I never repeated or even wanted to equal it again; once was enough. The forthcoming summer camp was my final one. Seventeen marked the age limit for stepping down, so that year I proudly wore a shirt stitched with badges, including that of King's Scout, which for years I had slogged hard to attain. I enjoyed enormously my years with the 48th Scout Troop but I had to move on. My job and, increasingly, my painting consumed more of my time and energy.

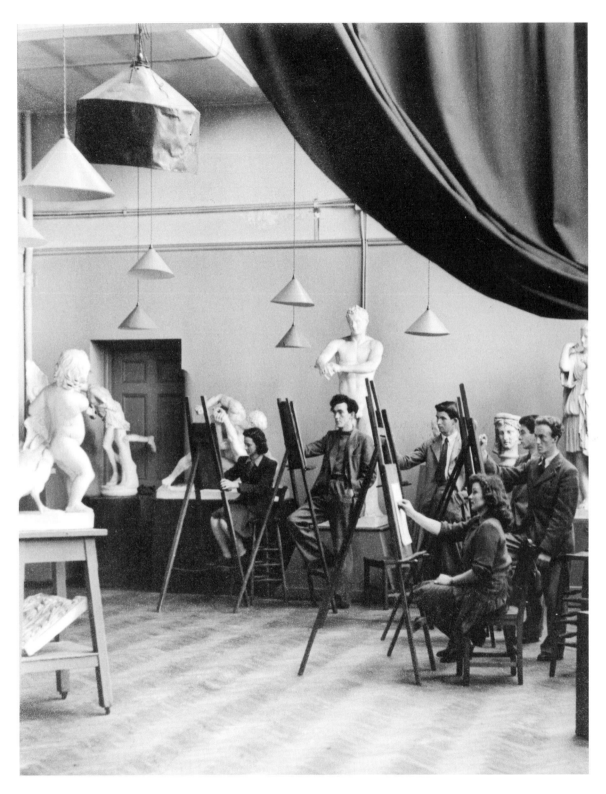

Belfast Art College, 1951
PRONI

6

One day Sam and I had just returned from our morning tea break when Bob Sprott, the office manager, handed me a brown envelope taken from a clutch of others in his fist.

'Must be your Christmas Box,' said Sam cheerfully. 'It's early this year.'

When I split open the envelope its contents left me goggle-eyed and almost speechless. The letter informed me that I must enrol at the Belfast College of Technology for a two-year night course in Mechanical Engineering. It also stated that the classes were held on two evenings each week from September until May. Uppermost in my head was the loss of so much painting time. I was furious.

'They can stuff their course,' I complained to Sam.

The grim facts twisted inside my brain all day long as I listened to five other apprentices who had received similar letters. Some of them were also adamant that they were not going to enrol. But, at the last minute and after much dis-cussion, we all buckled under and signed the forms for the duration of the course. We had little choice.

In less than two months I found that the coursework had slipped far beyond my understanding. My brain, capable of retaining for weeks or even months, exact details of buildings, colours and the atmosphere of a landscape at a given time, just could not cope with the formulae of advanced mathematics and

logarithms which were the main pivot of the course. My sole success was machine drawing. The lecturer praised the precision of my efforts but alluded strongly to other shortcomings and suggested that I concentrate on them if I wanted to pass the exams. By November two out of six of my fellow apprentices had quit the course and I wasn't far from doing likewise.

One evening during a break in lectures, I wandered off to explore the upper floors of the college and came upon two large statues standing opposite the stairway on the top floor. Mildly surprised by them, I walked along the corridor and, finding a door ajar, I gently eased my head around it. The room was empty except for a circle of about a dozen easels on which were drawings in various stages of completion. All were of a torso cast in alabaster which was displayed on a pedestal. I walked slowly past each easel and examined the drawings closely. Some were done in charcoal, others in pencil and in crayon. I stayed in the room for about ten minutes and then made my way to another room where I eased open the door and found a young girl sitting on a stool, engrossed in creating an oil painting. I excused myself and shut the door but not before I had taken a swift glance at all the artistic paraphernalia scattered around the room.

I hurried down to the main office and enquired of the clerk if the top floor was used for art classes. I was told that the college ran a three-year full-time course and that I would be required to pass an entrance examination if I wanted to enrol. They also offered night classes but the next registration was not until January.

I had discovered the Belfast College of Art and was completely gobsmacked by the fact. In all my years at school, not once did a teacher ever mention the fact that such an institution even existed, much less suggest that I try to enrol there. I had never heard my parents mention it either. I had just presumed that there were no local art schools and in truth the only one I had ever heard of was The Slade in London.

Having seen the students' drawings of the torso I realised that my own work could stand comparison with any of these and the knowledge gave me some satisfaction since I had come this far

Drawing from James's
sketchbook, 1943

without the benefit of formal tuition. I had always been very self-critical and was prone to destroying anything that did not come up to the standards I had set for myself. I never returned to the engineering course and in January 1944 I signed on for the night class in painting and drawing at the Belfast College of Art.

My tutor at the art college reminded me of Aubrey Beardsley, the Victorian artist. He was a long stringy fellow of about thirty, slightly bowed at the shoulders and inclined to peer at everyone over the top of his wire glasses in a very detached manner.

At the first evening class about sixteen students were seated around a pedestal on which was perched a very scruffy looking stuffed owl which stared defiantly at us with huge brown and yellow glass eyes. The tutor told us that we had two hours in which to complete a drawing of the owl and that we could take a break halfway through. Then, with a glance at us over his glasses, he left the room and did not reappear until fifteen minutes before the end of the session, when he began a hasty appraisal of everyone's work.

'Very creditable, yes, indeed, very creditable,' he droned, as he looked at my drawing before drifting over to an elderly lady sitting alongside me. He kind of drooped over her shoulder, pointed to something obviously not to his liking and, as she listened intently, I saw her face flush a little.

I watched him as he walked around, spending a minimum of time with each student and then after telling us to practice drawing at home, he softly flitted out of the room. Most people had managed to finish their drawing and did not seem to find anything amiss with the tutor's lack of attention but I had expected more than this from an art class and could only hope that things would improve as the course progressed.

After three weeks of sketching an endless array of stuffed birds and alabaster casts I was feeling very disgruntled by the tutor's lack of interest in actually teaching us anything and I finally asked him when we would be working with watercolours and oils. The very idea seemed to come as a shock to him and he told me that perhaps next year we might try some watercolours.

I moped the rest of the evening, beetle-browed at the thought of good money wasted on a course presided over by an individual who seemed to spend most of his time in some hidey-hole in the building, only making an appearance in the classroom for the final minutes of each session. I had just finished reading Somerset Maugham's *The Moon and Sixpence*. It was about a banker who had given up his career to become a full-time artist and it mentioned the Impressionist painters, Sisley and Degas. I had never heard of either artist much less the Impressionists and I was filled with curiosity about their paintings. I needed to learn about colour, composition and techniques, and something of the work of artists and the history of art in general. It was obvious that I had come to the wrong place for this and, completely disillusioned, I left the art course. At first I missed the company of the other students for we often had long conversations about art in general and about the professionals whose work adorned the walls of the galleries of Rodman and Magee. My preference was for the work of Paul Henry because I was greatly impressed by his figure work and his use of strong colours.

During the long winter evenings that followed, I began to resurrect the drawings I had done in the summer and from which I had hoped to produce a few paintings. Looking through the sketches I remembered that some of my erstwhile fellow students had remarked on the speed with which I could turn out a drawing and I reflected that if they had tucked themselves into street

corners or crouched on park benches surrounded by a nosy public as often as I had done, they too would soon have learned to draw quickly.

The previous summer the government had instigated a programme of events and entertainment called *Holidays at Home* and my sketches represented my impressions of the performances of singers, magicians, clowns, acrobats and band concerts that had taken place among the swings and roundabouts in the local park. Fascinated, I had joined the crowds who turned out to enjoy all these activities and I had often propped myself in odd corners or leant against tree trunks, busy with my pencil and sketchbook.

Sometimes I had drawn the brickworks on the Springfield Road with Divis Mountain glowering behind them or the round towered church of St Matthew with its satellite streets of red brick houses busy with people. Often I had walked through my everyday surroundings without ever noticing anything worth painting but now, for the first time, I began to paint the streets of Belfast shocked and bruised as they were in the aftermath of the Blitz.

One grey Saturday morning, as I stood in Magee's dithering over the multi-layered paint trays in search of colours, a voice by my elbow muttered, 'Try the lower trays, they're cheaper. That wee bastard Magee keeps the expensive colours on top. I wouldn't normally buy anything in this bloody shop but Rodman's don't have what I'm looking for.'

I turned and beheld a short lean man with deep brown eyes and longish black hair which was swept straight back off his forehead. His black moustache wriggled as he asked whether I was an art student. I told him I wasn't and then found myself recounting the saga of my experience at the College of Art. He laughed as the story unfolded and told me to count myself lucky to have been saved from the influences of the art school and that it was much better to follow my own inclinations. Probing further, he asked what subjects I painted and when I told him about my street scenes his eyes lit up. He said that he was working on some of those himself at the moment.

We talked for a time during which he asked my name and what I worked at and, in return, he told me that he and his brother shared a studio in Linenhall Street, above Hamilton's Garage. He invited me to visit him any Saturday afternoon and, if I liked, to bring along some of my work. His name was George Campbell and his brother was called Arthur. Then with a glance around the gallery walls he said, 'Nothing but crap and pot boilers hanging here,' and departed, leaving me with my jaws agape.

York Street after the Blitz, 1941

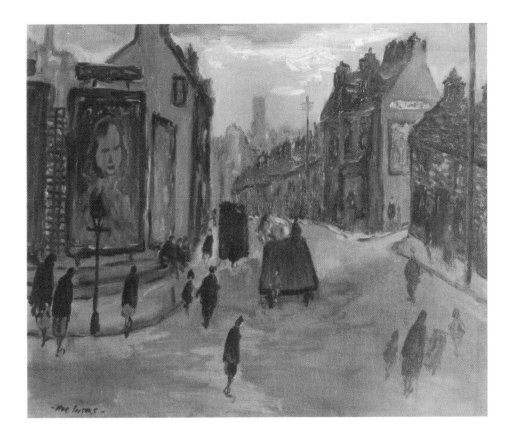

Peter's Hill, 1945

A week later at their Linenhall Street studio the two Campbell brothers greeted me warmly. Arthur, who was older than George, sucked a pipe and his conversation tended to be slow rambling monologues, interspersed by long silences which seemed to irritate his brother no end. Often, Arthur would unhook his spectacles, carefully breathe on them, give them a polish with his handkerchief and then resume his discourse. He was a gentle soul, inclined to take his time about everything and I liked him a lot. George, on the other hand, was aggressive and restless and I wasn't at all sure what to make of his incessant chatter.

Their studio was smaller than my own and to one side of the room a three-legged easel held an oil painting of a Belfast street scene. The colours were in shades of greys, browns, dark blues and black and the elongated figures with their tiny heads seemed very odd to me. It was a painting of such bleakness that I knew that I would not have wanted it on my studio wall. Over by the single window an unfinished watercolour sat on a desk. It was of a flower seller by the City Hall and even from across the room I could see it was brilliantly coloured. I wondered which brother had painted which picture and made a private guess that the gloomy one was probably George's work. I had brought along some drawings, watercolours and oils and the two Campbells began to examine them one by one, their silence unnerving me. When they had finished Arthur praised them and said that I undoubtedly showed promise and George agreed with him. George preferred the street scenes and Blitz paintings and I got the feeling that he thought I was wasting my time with landscapes.

Our conversation flowed back and forth from painting and painters to more personal topics. At one point Arthur told me that he worked as advertising manager for the *Belfast Telegraph* and that George had recently given up his job so that he could paint full-time. They confirmed my opinion that the painting of the flower seller was Arthur's work and that the dark one sitting on the easel was by George.

After a time George suggested that we should go out for a coffee, so we made our way to Campbell's restaurant in Donegall Square North. In spite of its name the restaurant had no family connection with the Campbell brothers and I was soon to discover that its top floor had the reputation of being something of a place of rendezvous for the artistic community of the city. We had barely seated ourselves when a dark, long-haired individual loped our way and sat down beside us. Arthur introduced us. His name was David Marcus Robinson but he was always known as Markey. He gave me a long stare and then asked if I was an art student. I shook my head at which he launched into a tirade against the 'lunatics' at the art college who were teaching the students to paint rub-bish. Then, hardly drawing breath and in very colour-

Arthur and George Campbell, 1944

ful language, he started to tell us what had happened to him the day before. Apparently, he had been sketching while seated on a wall near the military bar-racks on the Antrim Road, when he was spotted by a passing military police patrol and was promptly lugged, protestingly, into the barracks for questioning. He wasn't carrying his identity card or any other means of identification and after the army brought in the RUC he had his sketchbook confiscated. It was four hours before the police were satisfied that he was a harmless artist and not a German spy and he was eventually released, having given the name of John Hewitt, the Keeper of Art at the Ulster Museum, as guarantor.

'And the fascist bastards kept my drawings,' he roared, before downing his remaining coffee in one gulp and striding off.

Arthur and George were helpless with laughter at Markey's latest misadven-ture and as Arthur wiped the tear stains from his glasses, he assured me that I would get used to him. He was famous for his odd behaviour. That story, how-ever, left me feeling a bit uneasy as I recalled the many occasions when I had skulked around similar establishments with my sketchbook. I resolved never to go out without my identity card whose number I had long ago memorised – it was UADK211/3.

That afternoon, although I didn't realise it at the time, was the beginning of my artistic life. In time, through the Campbell brothers, I got to know other artists including Arthur Armstrong, Tom McCreanor, Dan O'Neill, and Leslie Zukor. We habitually met at either Campbell's restaurant or at meetings of the

Artists International Association which, before it managed to secure a top floor room in a building in Royal Avenue, had no fixed abode and its members, would meet at different venues.

On one occasion the meeting was held at the studio of the artist Sydney Smith in Howard Street. I thought the place fit for a king. A cornucopia of oil colours was spread in rows on a large desk, beside which stood three enormous earthenware jars, crammed with paintbrushes of all sizes. On a massive upright easel that looked capable of taking an eight foot by four foot canvas, sat a pokey little oil of the Ha'penny Bridge in Dublin. There was not much starving taking place in this particular garret, I thought to myself.

After the meeting we piled out onto the the street which, as if to spite the blackout, was silver bright against the silent shadowy buildings. Dan O'Neill lived in Dimsdale Street which was not far from my home and we set off to walk together. Dan was tall with long dark wavy hair brushed back from his forehead and, although initially somewhat reserved in manner, he mellowed on acquaintance and could become quite loquacious. He was working as an electrical engineer for the Belfast Transport Department and in order to get enough daylight hours to paint, he sometimes elected to work the night shift. That evening, as we walked home in the moonlight, I listened to him talking and quickly realised that he possessed a deep knowledge of painting techniques. I knew that he had never gone to art school and when I asked him how he came by this information he told me that it was all gleaned from books. I told him of my difficulties in getting the right kind of books and he suggested that I try the reference section in the Public Library in Royal Avenue. He told me to ask for the librarian, Bob Jenkinson, and explained that although strictly speaking the books were for reference only, Mr Jenkinson would sometimes allow one to be borrowed for a weekend.

When we arrived at Dan's house he asked me if I'd like to see his latest paintings and as he opened the door he reached inside his coat and slipped out three paint brushes. 'Smith has too many brushes so he won't miss these and I'm skint,' he said.

The living room in his house was so tiny that I couldn't imagine how he managed to find any space in which to paint. He disappeared into the little kitchen whose doorway was hung with a curtain and came back wielding an oil painting. It was a winter landscape, its foreground a mass of frosted, twisted branches from which hung an iridescent spider's web that glowed against a blue-black sky. Dan watched me with obvious amusement as I sat with my nose almost touching the painting, trying to figure out how he had painted it. It was very simple, he told me. He had invested in a tube of toothpaste, cut the bottom off, removed the paste and refilled the tube with oil paint. Next, he placed a thin

Flower seller, 1947

nail inside the nozzle and with the aid of a pair of pliers, carefully tightened it to a reduced diameter. When the nail was removed and the tube gently squeezed, it produced a line of paint of consistent size which was something not easy to obtain using a brush. His ingenuity astounded me.

Our conversation was interrupted by the clock on the mantelpiece striking one o'clock. We had been so engrossed that I had not been aware of the passing time and as I took my leave of him and started home, I barely noticed the eeriness of the deserted streets. I could think only of his paintings and his total commitment to his art and his will to survive whatever the odds. Among this group of painters I was the youngest by at least ten years. They were endlessly tolerant of my questions and I became more determined than ever to emulate them and to try and make my own way in the world of art.

When the Allied Forces stormed the beaches of Normandy in June 1944 da declared with considerable satisfaction that, in his opinion, Hitler was now in serious trouble.

Then one day in October of the same year I came home from work to find that a cablegram had arrived from Canada, telling us that my Uncle David, da's youngest brother, had been killed in action in France.

David had gone to Canada in the early 1930s and there he had met and married a girl from Scotland. To da's great displeasure he had enlisted in the Blackwatch Regiment of the Canadian Army in 1944. It was not lack of patriotism that was the cause of da's opposition but rather the fact that David, who was by this time in his late thirties, was leaving behind his wife, Betty, and their three young children.

Sheared sheep, 1947

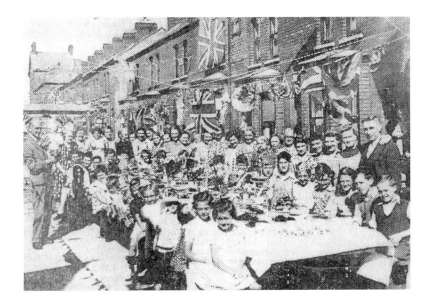

My father had lost a brother in the First World War and now in the final months of the second he had lost another. Da was a quiet man and when the cable arrived he read it and then sat for a long time in silence, before reaching for pen and paper to write to Betty. After a while he got out his bicycle and rode off to his garden plot at Wolfhill. When, some hours later he returned, he was still wrapped in his private grief and saying little to us he just had his dinner and then buried himself behind the newspaper.

At long last the war in Europe was over and to mark the occasion the government declared a country-wide holiday on the 8 May 1945. Flags and bunting festooned the streets of the Shankill and parties were organised for the youngsters. Tables and chairs, hoisted from homes, were laid end to end down the middle of the streets and very soon they were weighed down with plates of sticky buns, bottles of lemonade and steaming kettles and teapots. All this to the accompaniment of much singing and dancing and good-natured chatter.

In the afternoon, the city centre thronged with thousands of people, all gathered around the City Hall for the march of the various armed forces. Later in the evening the City Hall floodlights were to be switched on for the first time since the war began. And, as dusk fell, every house seemed to be lit up with people out singing and dancing to the accompaniment of various musical instruments. As I walked down the Shankill Road, I saw bonfires send licking tongues of flame up into the night air, which pulsated to the beat of the Lambeg drums. The road was crowded with people and I saw several brightly lit trams marooned, unable to move in the stream of bodies moving by.

James in Arthur Armstrong's studio, 1945

Around midnight I dropped into bed, weary but happy that the war was over, and I reflected that we had been very lucky to have been able to spend

the worst of the Belfast Blitz in Greenisland. However, for Northern Ireland as a whole and for Belfast in particular, the cost of the war had been formidable in both human and economic terms. Over 1,000 civilian lives had been lost in the Blitz and 2,500 people had been injured; a further 100,000 had lost their homes. It was calculated that 56,000 houses had been damaged and 3,200 completely destroyed. It is not often remembered that in Belfast, in one single night, as many lives and homes were lost as in similar raids on London and Coventry.

Next day I returned to work and soon wished I hadn't. I had been lying in an awkward position beneath a van, loosening rusted exhaust pipe bolts, when the head of one sheared off and the spanner flew backwards and belted me across the right eyebrow. Blood spewed down into my eye and the pain was excruciating. I lay dazed for a few seconds before I finally dragged myself out and examined my bloody face in the wing mirror. Sam rushed over, tilted my head back and held his handkerchief tight over the wound. A few seconds later he lifted it to see the damage.

'You're a lucky bugger, an inch lower and that spanner would have taken your eye clean out,' he said grimly. He propelled me to the office where someone cleaned the cut and decided to my relief it didn't need stitching.

Next morning my eye was almost closed and my eyebrow had swollen to twice its normal size and glistened in shades of blue and yellow. Da said I looked like I had been scrapping in the ring with Joe Louis. A week passed before I returned to work and even then my eyebrow still had a small bump the colour of a duck's foot. Six months previously we mechanics had all joined a union in an attempt to force the management of Coulter's to tackle the

Rocky landscape,
1947

problem of diesel fumes on the upper floor of the building; these fumes were blamed for causing constant headaches among the men who worked there. In my absence the builders had been busy on the rear wall, installing a massive fan.

Old woman, 1946

I sometimes tossed a coin on Saturday afternoons as to whether I should visit the Campbell brothers or the reference library. Dan O'Neill had given me a list of painters to read about and Bob Jenkinson went to endless trouble to satisfy my needs, even to the extent of borrowing books from London. However, my growing understanding of the work of modern and impressionist artists influenced me so much that I began, unconsciously, to imitate them and this worried me slightly. One week I would turn out work in the style of Van Gogh, then it might be Utrillo or Renoir and when I mentioned this to Dan, he laughed and told me this was something that happened to nearly everyone and that it would pass.

When I told George what was happening he waved his hand airly, told me to forget the books and just get on with my own work. I could not agree with him for I had become aware that some compositional changes had occurred

Still life, 1947 in my paintings which I thought made them more interesting. George, however, liked to have the upper hand in any discussion and was less than pleased that I did not accept his advice.

It was around this time that he introduced me to two other young artists, Arthur Armstrong and Tom McCreanor, and we were to become lifelong friends. The three of us often went on drawing expeditions to Carr's Glen or to the slopes of Cave Hill and the quarries at Ligoniel, but most frequently to a little huddle of houses tucked in a valley below Wolfhill mill. One such Saturday afternoon, as we stood on a hilly lane engrossed in our sketching, I noticed without much interest, a trickle of water flow downhill between my feet. I absently watched the flow for a moment and then continued with my drawing. A few seconds later I became conscious of a warm wetness on one of my legs and when I bent to examine it I realised that a passsing dog had lifted its leg against mine and that I was soaked to the skin. Cursing, I yanked out handfuls of grass to scrub myself dry while the other two watched, helpless with laughter. The thing that amused them most was the fact that I had not even been aware that there was a dog around!

One day we were all in Campbell's restaurant filling our guts with wee buns and coffee, when in strolled a slightly tubby figure, sporting a large grin and a duncher. He spotted George immediately and made his way over to our table. George introduced us. The newcomer's name was Gerard Dillon.

Gerard, originally from Belfast, had arrived from Dublin the previous evening and intended remaining for a short spell, before going to London to stay with his sister Mollie. His conversation was all about Dublin and its artists and galleries. George had also recently been to Dublin and planned a one-man show at the Victor Waddington gallery which was to take place sometime in 1946. When he told Gerard about this, Gerard said that he had encountered Dan on a Dublin street, in a very drunken and euphoric state because he had just sold Victor Waddington some of his paintings and had also arranged an exhibition for 1946.

We younger artists listened all ears, as the conversation between Gerard and George swung between painting, their relentless penury and struggles to survive from week to week, often on a diet of bread and spuds. The Ulster public, it seemed, were not much given to buying paintings and when they did it was usually from recognised names such as Conor, McKelvey, Craig or Wilks rather than young unknowns. To hear these two argue was an entertainment. As he talked, George would become more and more animated and bite his nails, pull distractedly at his wee moustache or scratch his behind while all the time flicking cigarette ash all over himself. Gerard would bait him mercilessly and then watch his antics with laughing eyes.

That evening when we parted company outside the restaurant, Gerard passed us his mother's address and invited us to call anytime if we felt like it. Not long afterwards I did call on Gerard, at home in Clonard Street on the Falls Road, but there were so many people milling around that we couldn't find a place to sit down. He suggested that we walk into the city centre for a cup of coffee.

Gerard was a time-served house painter and his familiarity with paints and materials had led him to use careful methods for priming his canvases and had furnished him with an understanding of drying times and overpainting when using oil colours. At times he painted on thick cardboard primed with as many

Running close,
1946

as three coats of size. Both he and Dan were meticulous in preparing their working surfaces. George, on the contrary according to Gerard, was handless. He had no patience, was not methodical and Gerard said he had even been known to use lighter fuel as a medium because it caused the oil paint to dry overnight. He had tried to talk George out of the practice as it was certain to cause difficulties later on for the paintings concerned. In this, of course, Gerard was proved right for within about four years, tiny cracks opened up on the pictures and the paint lost its surface. He also grumbled about George's habit of overpainting his old pictures and not taking the trouble to remove the original raised and hardened paint, which invariably appeared in the wrong places beneath his newer work.

Gerard and George had first met in 1942 and George, although he had been drawing for years, knew practically nothing of oil painting techniques until Gerard took him in tow and explained the various methods. George must, at least for a time, have been strongly influenced by Gerard's paintings for Gerard, who had been in the habit of depicting 'shawlies' in his work, decided to stop using them because he said that every time he looked at a Campbell oil there they were.

Our conversation turned to the Blitz and Gerard told me that he had framed his paintings of the carnage with scarred timber taken from bombed sites.

'People bought them and they imagined I was so hard up I couldn't afford to buy frames,' he chuckled.

I thought this was inspirational.

Like myself Gerard had attended evening classes in art for a short spell and then given them up, convinced that artists should teach themselves or learn from other practising artists. At this time he was still officially living at Clonard Street but he found it difficult to paint in the crowded space and tended to spend a lot of time in Dublin, where he used a flat owned by fellow artist Nano Reid, or in London with his sister. He always painted Irish themes and had recently spent two weeks in Connemara where he had amassed enough notes and ideas to keep him painting for months.

I was to discover that Gerard loved a good gossip and over yet another cup of coffee he talked of the uneasy relationship that existed between Dan and George and told me that in private, neither of them was above heaping ridicule on the other's work.

Later, as we made our way home, he asked if I wanted to become a full-time painter and I told him it had always been my objective.

'Well, we need a bit of luck in this profession but mostly it's just hard work and perseverence. George seems to think you might make it,' he told me. This last bit, naturally, was music to my ears and as I left him at the street corner I was feeling pretty pleased. It was to be nearly a year before I encountered Gerard again.

In September 1946 the Artists International Association probably enjoyed its Belfast heyday when an exhibition was organised at the Royal Avenue venue. For the younger members it offered an opportunity to display their work and for some, including myself, it was the first time that they had taken part in an exhibition. Among those exhibiting were Max and Gladys MacCabe, Olive and Marjorie Henry, Renee Bickerstaff, Ken Bloomfield, Markey Robinson, Tom McCreanor and Arthur Armstrong.

Markey caused the Association some angst when he pleaded poverty and failed to produce his subscription fee. The committee insisted that he could not exhibit unless he coughed up but he kicked up such a fuss that they finally caved in and allowed him to hang his work. During the opening ceremony he strutted around offering everyone advice on how to paint. At one point he accused one of the other artists of copying one of his paintings and passing it off as his own. This, of course, nearly caused a punch-up. However, physically facing up to Markey might have been a mistake as he was known to have been an amateur boxer in his time.

The Association enjoyed visits from Sam Hanna Bell, Denis O'D Hanna and John Hewitt, who once gave us a lecture on Irish artists. At this time the secretary was Joan Day and later Tom Goeritz. But, interest in the Association gradually waned over the next two years and I remember it mostly for the people I met and remained friends with for many years.

James in 1946

George knew almost everyone involved in the arts in Belfast and through his interest in the theatre he met Hubert and Dorothy Wilmott who ran a drama group called the Mask Theatre in Linenhall Street. Early in 1946 the group moved to a huge attic in Upper North Street which was able to accommodate about one hundred people and became known as the Arts Theatre Studio. One Saturday afternoon George propelled four of us – Arthur Armstrong, Tom McCreanor, Gladys MacCabe and myself – around the theatre and suggested forcefully that we should paint images of our choice on the largest cardboard panels we could find. The aim being to provide some decoration for the blank theatre walls. Of course, there would be no fee and we would have to buy our own materials but the publicity would be good for us and we would be given free theatre tickets said George generously.

Clown, 1948

The place did look a bit dismal; they were after all a struggling company, so we nodded at each other and promised to produce the panels. I painted three clowns in various action poses and when everyone had mounted their work on the walls the theatre certainly looked brighter. Hubert and Dorothy were profuse in their thanks and they handed over complimentary tickets to the five of us. George, albeit at the last minute, also produced a panel.

The painting of these panels led to us becoming acquainted with some of the actors and, therefore, even more people to chat to over coffee in Campbells. Among those we met at this time were Harold Goldblatt, Jimmy Ellis, W. H. McCandless and Harry Towb. Harry, whom I had previously met at Coulter's, was the fond owner of a battered Ford 8 which, at first sight, looked ready to disintegrate, but somehow Harry always managed to coax enough spark from it to rattle around Belfast.

Coulter's wearied me. I disliked going there every morning to spend my day fiddling at disabled cars and trucks when I had long since discovered that I had not the slightest appitude for, nor interest in, mechanical engineering. I found it easy enough to dismantle a vehicle's components but the trouble arose when I tried to reassemble them. I could never remember which bit went where and what was even worse I didn't really care. Sam would nod towards a dead engine, tell me to check out its problems and start it up. Half an hour later it would still be sitting silent. In despair he would shake his head, poke, screw something, pull the starter knob and like magic the damn engine would kick into life and spew out a few hefty belches of smoke.

In his efforts to spur me on to greater things, mechanically speaking, Sam

would often declare that if ever I actually made it to full-blown mechanic and had an apprentice of my own, the apprentice would probably end up having to show me what to do. I did have one success though; I learnt to drive surprisingly quickly and without any mishaps.

Soon, the end of my apprenticeship was looming and the prospect filled me with apprehension. I would then be a bona fide mechanic and trapped. For some time I had been mulling over the decision to give it up and try to make a career in art but the prospect of breaking the news to my family was daunting. They were still expecting me to work for my Uncle Jim in his garage even though they said Uncle Jim was showing scant interest in resuming it. He enjoyed his job at Shorts and was not inclined to give it up for an uncertain financial future. In the Linenhall studio I discussed the problem with George who, fixing me with steady brown eyes through a haze of cigarette smoke, heard me out and then bluntly told me to make up my own mind.

When George had left Shorts he had given himself four years in which to accomplish a foothold in the art world. Now he was over the initial hump. Dublin beckoned and if he kept his nose to the grindstone he was hopeful that some success might be coming his way. George was of the opinion that the art buying public of Belfast left a lot to be desired. With the exception of a few spirited souls they were just not interested unless paintings portrayed the traditional style of landscape in the manner of McKelvey and Wilks. In George's opinion McKelvey and Wilks painted solely to please their customers and he was quite contemptuous of them for this reason.

The January day had been cold, clear and bright and in Coulter's workshop the temperature hung low. A Ford 8 was in need of a new radiator and Sam and I were allocated the task of fitting one. Since all the pits were occupied, Sam asked me to crawl under the radiator, loosen the bolts and drain the water into a tin tray. Consequently I was lying flat on my back under the car with my head turned sideways when an unexpected movement beneath caused me to shoot upwards a few inches and I felt my head suddenly clamped hard against the bodywork of the car. For an instant I thought my skull was going to be crushed and I howled in alarm. Immediately, I felt the pressure lessen and someone grab me by the legs and haul me out from beneath the car.

I felt bewildered, my head was aching and I was aware of a wetness on my left cheek and thinking that the radiator had leaked over me I put up my hand to wipe it. It came away streaked with blood. I heard people shouting at me to lie still but I turned on my side and sat up. A van appeared on the scene and I was lifted inside it with my head resting on a car seat while Sam clambered in beside me. As the van raced towards the hospital I asked Sam what had happened and he told me tersely that I had managed to get my head trapped in a ramp.

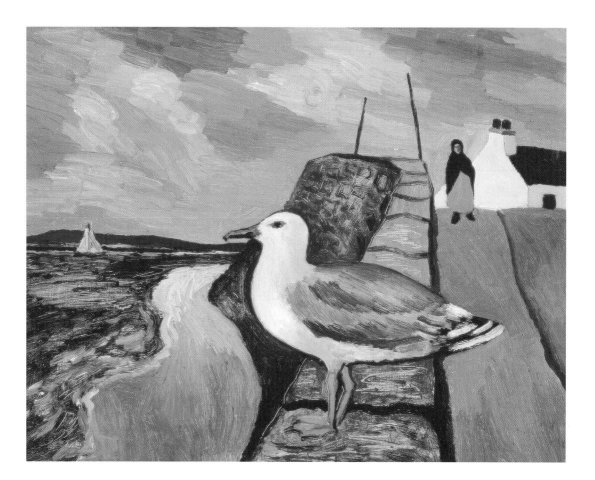

Seagull, 1946

At the hospital the doctor gently felt my cheek and did various tests which entailed me moving my jaw in different directions, opening and closing my mouth and stretching my head backwards. After about half an hour he seemed satisfied that I was not seriously injured and told me that I could leave but to come back immediately if the pain got worse or if I felt any serious discomfort.

Back at Coulter's I discovered what a lucky escape I had actually had. While I had been under the Ford 8 someone had opened up one of the pits and had tossed out some heavy planks. One of these had hit the lever on the wall which triggered the disused ramp. The ramp itself, in its dormant state, was flush with the ground and one of the car's rear wheels had been partially resting across it. When the lever had been activated, the ramp rose, trapping my head between it and the underside of the car. I owed my life to the fact that the car had been in neutral gear with the handbrake off. The movement caused it to roll backwards thus releasing my head.

It was four o'clock and nearly dark when the van, with Sam driving, delivered both me and my bicycle home. Ma was initially almost speechless with shock at my appearance but when she heard the full story from Sam, she quickly gathered steam and lathered into Coulter's management, berating them for their disregard for the safety of their workers.

By next morning my cheek was displaying a big blue bruise with long bloody scratches etched into the skin and my jaw felt very stiff and sore. It was

more than a week before my face returned to anything like normal and in that time I had a visit from Sam who told me not to be in any hurry to return to work. I assured him that nothing was further from my mind than Coulter's workshop. Ma thought Sam a very nice polite sort of man and I smiled to myself thinking that Sam had completely charmed yet another lady.

It was to be three weeks before I was fit to return to work and in that time I had been able to accumulate as many paintings as would normally have taken me months to produce. I had also done a lot of brooding about my future and had made the decision to leave Coulter's and take up painting full-time. The problem was how to tell my parents of my choice. I had tried to break the news by making oblique remarks about the subject but this tactic was received in silence and in the end I just came out with it. To my surprise they seemed resigned to the fact. Perhaps my recent narrow escape had something to do with their attitude because when I finally told them I thought they seemed relieved.

A short time before Christmas, a friend called David Harrison who owned the Chalet D'Or cafe in Wellington Place asked if I would like to show some paintings there. Now, weeks later, as I climbed the long stairway to the cafe, I was planning how I would get all the paintings transported back to the studio. David met me with a broad smile which quickly turned to a look of horror when I told him of my accident and why I had not been to see him sooner. He ushered me into his office and offered me a coffee while he opened a heavy tin box and handed me twenty-five pounds in white five pound notes. All six of my paintings had been sold and I was speechless with astonishment and delight.

Later, I made my way to Campbell's restaurant and on entering I spied George, sitting near the window with two of his thespian cronies. I could see immediately that some sort of heated discussion was taking place. George barely acknowledged my arrival as I pulled up a chair and sipped slowly at my coffee, preparing to listen in on the debate. The gist of George's argument was that creative people such as artists and musicians had brains that were different from other people's. George, for the moment, had a fixation on brain function, tomorrow it would probably be something else, so I listened as he rattled on.

It seemed that he had spent the previous evening in the company of Tom Davidson who was a very talented pianist and mutual friend of ours. They, no doubt deep in their cups, had discussed this neurological phenomenon at great length and had come to the conclusion that it was an innate faculty of eye and hand coordination, peculiar to pianists and painters. Both Tom and George were extremely argumentative characters and I was mildly surprised that they had agreed on anything. George's companions heard him out and then heaped his head with ridicule before they took their laughing departure. However, I thought that he had a point.

When they left George finally gave me his full attention and demanded to

know where I had been for the past few weeks. I told him in detail what had happened in Coulter's and his face grew sombre. He said that I was running out of lives and that I should get out of Coulter's while I was still in one piece. I nodded in agreement.

'Well now,' I said, changing the subject. 'Listen to the good news,' and I told him about my success at the Chalet D'Or and produced a fistful of fivers to back up my story.

I had scarcely finished talking when I found myself being propelled in the direction of the Washington Bar where George ordered two bottles of Guinness, clearly expecting me to pay for them. I eyed the Guinness with some misgivings. I had never had an alcoholic drink in my life and said so. George just grunted, slowly sipped the creamy froth from the top of the glass, licked his lips and told me to shut up and swallow it down. I looked at the drink and after sniffing it, screwed up my nose with distaste. I took a mouthful of the dark brew and found the bitter taste of it to be as vile as I had expected.

'Oh, stop girning. By the time the glass is half empty you won't notice the other half slipping down,' said George, slugging another mouthful.

Fifteen minutes later I found myself out in the street swaying like a flagpole in the winter wind, while George hopped around, yelling in my ear that the tram stop for home was just across the road. Then, muttering something about the absurdity of some people getting pissed on one glass of Guinness, he disappeared in the crush of pedestrians leaving me standing on the pavement. A wry memory came to me of a day in school when our entire class had declared its allegiance to the Temperance Society and had duly signed the pledge. To clear my head of fuzziness I wandered slowly around the city centre for a bit, hoping that by the time I got home ma's sense of smell would be blunted by da's fug of tobacco smoke. Thankfully I struggled into bed, sways unnoticed.

The morning was bitterly cold as I prepared to cycle to Coulter's for my first day back since the accident. Ma kept nagging me to take care on the roads as the overnight frost had made them treacherous. I was only half listening to her as my mind was on the day ahead. I felt that I was going to meet my destiny head on for, with only three months of my apprenticeship still to run, I had decided that this was the day I would hand in my notice.

Sam was genuinely chuffed to see me back which was more than I could say about being there. After asking how I was he turned his head and nodded towards the offending car ramp. I saw that the lever had been disconnected and the ramp was now inoperable. Sam rolled his eyes indicating his disgust that this action had not been taken long ago. He then told me that Bob Sprott, the office manager, had asked to see me in his office but he had no idea why.

I liked Bob Sprott. He knew about my artistic leanings and frequently asked

how my painting was progressing, if and where I was exhibiting, or which books was I reading.

When he met me in his office it was to tell me that Coulter's had offered to let me finish the rest of my apprenticeship working in the general office. This was in order to give me a break from the workshop and time to recover fully from my close encounter with eternity. I thought quickly. Three months in a cushy office job with a salary every week would soon pass and then I would be free. I accepted the offer.

Later, when I talked to Sam about it, he was of the opinion that the management had a bad conscience about my accident. Paddy Fegan, the union representative felt very strongly that the offer of an office job was a breach of contract on the part of Coulter's and he said he would take it up with the union. However, I explained to him that if they hadn't offered me the job I had been going to give notice and, in any case, when the three months were up I was leaving anyway. Paddy was astounded at this piece of information and wanted to know if I was mad. He pointed out that when my apprenticeship was over I was due quite a hefty increase in salary. I shook my head and told him I didn't care. I was leaving.

I spent the next three months working in the office and soon discovered one of the disadvantages of my new position. I had to work on Saturday mornings.

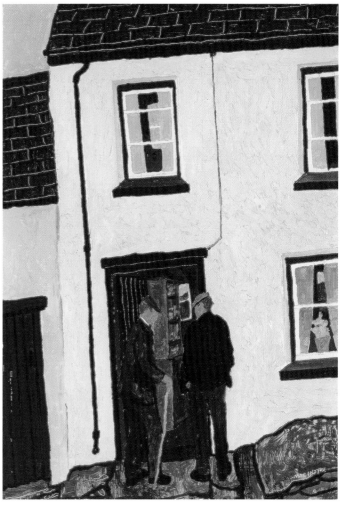

Men at Glenoe village, 1947

This would not have mattered had it been later in the year but the short daylight hours of winter seriously curtailed my painting time and the loss of Saturday mornings was very irksome to me. Three months later I wished Sam and the others all the best, walked out through the huge garage doors and never returned.

Ma's only comment when I got home was, 'I hope you are doing the right thing.'

As to that observation I felt that only time would tell. For the moment I had accumulated enough money to give me some sense of security and I was eagerly looking forward to producing paintings for a group exhibition which George had proposed for January 1948.

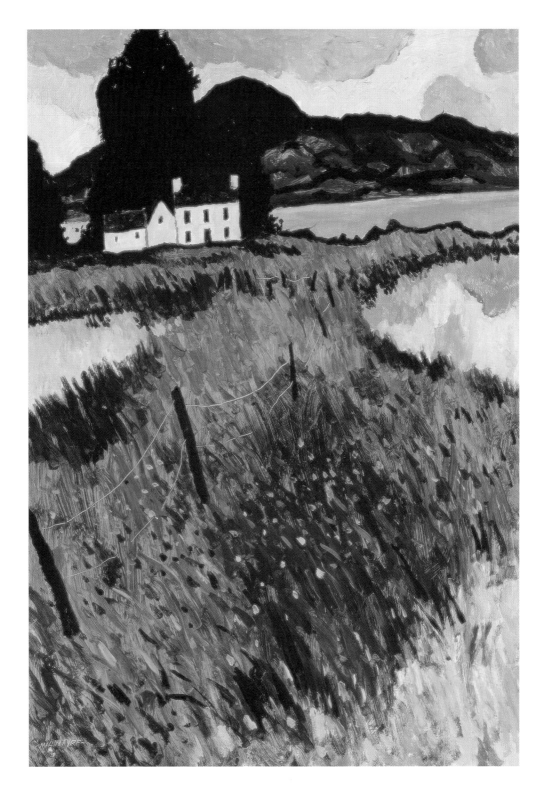

House in bogland
1947

7

In 1947 the film *Odd Man Out* was shown in Belfast. It was based on a thriller by the English novelist F.L. Green, who had lived in Belfast since 1932, and was the story of an IRA gunman called John McQueen. The part of McQueen was played by James Mason and the film used background shots of the Crown Bar in Great Victoria Street and various shots of Belfast backstreets as well as an incident on a Belfast tram. All this local interest, of course, made the film very popular.

One of its characters was a mad artist called Lukey Malquin who was robustly portrayed by Robert Newton. It was rumoured that Markey had been friendly with the author F.L. Green but that after Markey had seen the film, their friendship hit the skids because Markey was convinced that the outrageous Lukey Malquin role was based on himself. In any case, he became determined to sue F.L. Green for defamation of character and told us often that he intended to consult the best barrister in town and that between them they would relieve F.L. Green and the film's director, Carol Reed, of a hefty sum in damages.

In Campbell's Markey's coffee-swilling friends would clap when he appeared and then proceed to wind him up about the progress of his lawsuit. I remember Sam Hanna Bell and Jack Loudan, who was head of CEMA – Council for the Encouragement of Music and the Arts – the forerunner to today's Arts

Council, telling him they would be asking for a loan. Even Willie Conor joined in the banter. George suggested a celebration party when Markey had won the case and was in the money. The acting fraternity inferred that all the publicity would make him famous and directors would be seeking him for film parts. There were times when I felt very sorry for the poor sod.

Dan, who had moved house with his wife Eileen to Conlig in County Down, was now a relatively rare visitor to the restaurant but one day he unex-

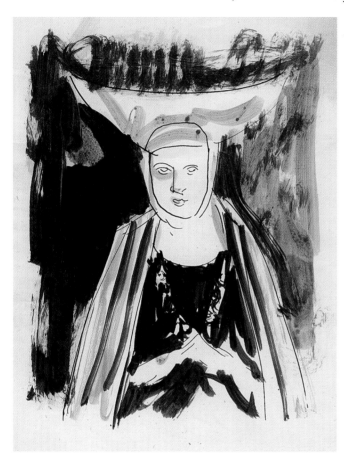

Nun, 1947

pectedly appeared and was immediately greeted with enthusiasm. He talked about his life in the sticks and his painting. It seemed that his business relationship with the Waddington Gallery was going well and he told us he was now on a monthly retainer. This seemed to be a bit of a mixed blessing for although it was good to have a steady income, Dan worried continuously that his paintings would not sell fast enough to cover the retainer and he might find himself in debt. However, his talent and growing success, coupled with his tall good-looking presence, had inspired one female columnist to describe him recently as, 'the most gorgeous artist in captivity'. Needless to say, Dan took some stick over that.

Then the conversation turned to Markey and his fixation on suing F.L. Green. It seemed that no sooner had his name been mentioned than the man himself came hopping up the restaurant stairs and dragged a chair over to join us. Markey immediately and excitedly launched into a story about the astronomical fee demanded by a barrister to take his case. Dan, who had never had much time for Markey and his histrionics, now eyed him with obvious impatience as he ranted on. Eventually, Markey paused to take a gulp of coffee and Dan suddenly erupted.

'Markey,' he roared. 'What the hell are you going on about? If you ever get to the witness box and a bloody judge in his wig has to sit and listen to all your crap it will only take him two minutes to realise that you're a buck eejit. Everybody knows you're a nutcase, so for God's sake, give up the idea and go home and shut your face.'

Poor Markey's mouth went slack and he looked completely stunned. Without a word he stood up and left. Markey never mentioned the F.L. Green affair again and neither did we.

One day ma answered a knock on the door to find a tinker woman with an

infant swathed in a grubby blanket standing on the doorstep. Out of compassion for the child ma handed the woman a threepenny bit. News of her generosity must have spread through the tinker community for over the following week so many beggars turned up at our house that ma was forced to take refuge behind the parlour curtains every time the door knocker rattled.

In the past I had often passed tinker encampments and admired their gaily painted caravans and now I decided to go in search of one, thinking to make some drawings. I found the camp off the Upper Springfield Road. It was strewn across a sloping rush-filled field and consisted of six caravans, side carts and low tents. All the caravan doors faced due east, away from the prevailing westerly winds which whipped the smoke from their campfires briskly away, across the field. Some children were playing noisily behind one of the caravans but otherwise the place seemed almost deserted. Far in the distance, in the bowl of downtown Belfast, tall chimneys smoked and endless little houses huddled beneath the industrial haze.

As I slowly approached the camp I was cautious as the tinkers had a reputation for not appreciating the attentions of strangers and for being handy with their fists. Eventually I found a spot about fifty yards from the nearest caravan and sat down to draw. It was not long before a couple of ragged youngsters sidled up and after peering over my shoulder they galloped away. A few minutes later they were back, accompanied by a tall dark gangling man. He wore a broad-brimmed hat tucked low over one eye and around his deeply tanned neck was knotted a red and white spotted scarf, the ends of which trailed in the wind. For a few seconds I contemplated flight but then he smiled at me and I relaxed.

'Are you an artist?' he asked in a strong southern brogue as he sat himself down beside me.

I held out my sketchbook and he examined my work for a few minutes and then rising, he asked me to follow him across the field to the rear of one of the caravans. There he stood back beaming and indicated to the wall of the caravan where, on a panel under a little curtained window, he had painted colourful designs of surprising delicacy. They were beautiful and I told him so. His name was Clarence Lee. It was a name to be proud of he said for he was recognised the length and breadth of Ireland for his skill as a decorative painter. Indeed he had even had requests from across the sea for his talents. He wanted to know how much I charged for my paintings but when I told him he refused to say in return how much he was paid for his designs. He made the point that because decorated caravans roved freely over the whole country, everybody could enjoy his work, while mine was bought by rich people and hung in their houses for their private pleasure.

For a long while we stood leaning against a cart discussing colours and

Clarence Lee, 1947

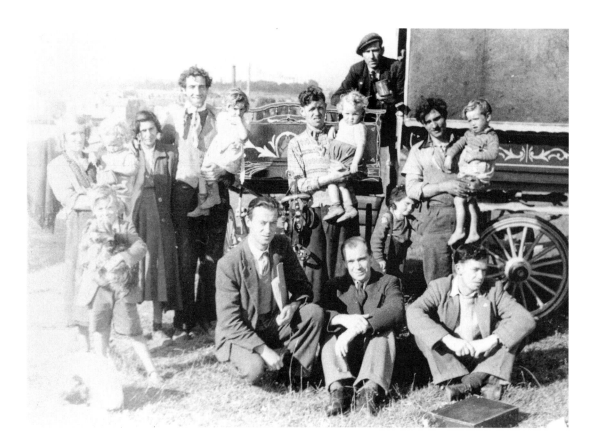

Clarence Lee, James (seated right) and Liam Andrews (kneeling left, front row) at Springfield Road camp, 1947

designs and he explained his method of producing the very thin long lines for decorating wheel spokes and rims. They were done with a lining brush consisting of a tiny shaft, barely an inch long, but with hairs that were nearly a foot long. It was work that required some considerable skill. Clarence said that he rarely left the camp as his work kept him constantly busy unlike the other tinkers who were out most of the day foraging or selling their wares. This fact, I realised, accounted for the deserted feel of the camp when I had first seen it. Clarence acted as a kind of watchman for the camp.

I did not get much drawing done that day but in Clarence I had made a friend and he told me that the tinker clan would be camped at this site for at least a month. He said I was welcome to return whenever I liked. As I walked back home I was certain of being able to produce a series of paintings of the tinkers for already my imagination had taken off and they were stringing themselves together in my head.

Because of bad weather it was to be several days before I went back to the camp. When I did, I found that someone else had been inspired by the sight of the tinkers, for I found another artist already there making notes. His name was Liam Andrews and he lived just across the field from the camp. Liam had also met Clarence and had suggested to him the possibility of inviting the BBC to come and record some of the songs and traditions of the tinkers. Clarence, being a bit of a showman, was enthusiastic at the idea of hearing himself on the wireless and promised Liam that he would organise a group of good talkers and singers.

Meanwhile, I had brought with me a rucksack full of old clothes courtesy of

ma and I noticed an old woman rustling a campfire into life and asked her if she would like to have them. Her face lit up with delight and she heaped upon my head a profusion of blessings including good health, wealth and a long life. Hauling the rucksack to her caravan I glanced inside and what I saw left me blinking in astonishment. The place was crammed solid with a hodgepodge of articles. On one side was an unlit iron fireplace, its steel chimney poking through the canvas roof, and beyond that sat a small table with the floor beneath it heaped high with cardboard boxes of varying sizes. The rest of the floor area was scattered with cooking pots, a kettle, buckets, a coal bin and other odds and ends. Only two chairs were visible.

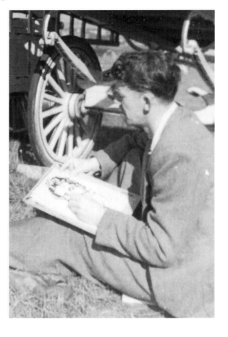

At the rear, bisecting the little window with its neat green curtains, was a bunk bed, beneath which was a row of cupboards painted yellow and red. The height of the bed was such that it was difficult to imagine it left enough headroom for anyone to actually sit up in it. Along its outside edge the bed had a very nicely made wooden lattice, with little turned knobs which I presumed were there to prevent its occupants from falling out. The wall behind the bed was festooned with an assortment of photographs including one of the Pope and a poster of the Sacred Heart while the other walls were completely covered with prints of flowers and landscapes. I reflected that it must have been very pleasant to drop off to sleep surrounded by a montage of all your favourite images.

James sketching at the gypsy camp, 1947

I had been so mesmerised by the scene inside her home that I had almost forgotten the old woman. I became aware that she was watching me closely and I quickly assured her that I thought the caravan was beautifully decorated.

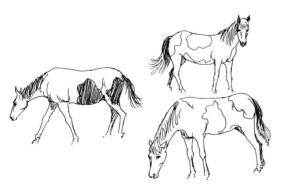

Sketch of horses at the camp, 1947

I threw the empty rucksack on the ground outside and sat down on it to begin drawing. Some black and white piebald ponies tethered by long ropes were grazing the meagre grass, occasionally waggling their manes and raising their heads to stare around. I filled page after page of drawings of them as they continually shifted position. Then, to my amazement, a young boy appeared and unleashing one of the ponies he jumped on its back and tore across the

field riding bareback and whooping like a Red Indian on the warpath. He was closely followed by three yelping dogs which seemed to upset the pony so that it neighed and kicked its legs in the air almost throwing the rider. Absorbed in the scene before me I continued to draw.

Suddenly I became aware of a rhythmic noise at the far end of the camp and when I looked over I saw a seated figure bent low hammering at something. Then the man got to his feet and lifted a rolled metal sheet which flashed in the sunlight. It was a tinsmith at work. I headed his way and asked if I could watch him work the tin. He replied that I would be no bother at all and I settled myself beside him.

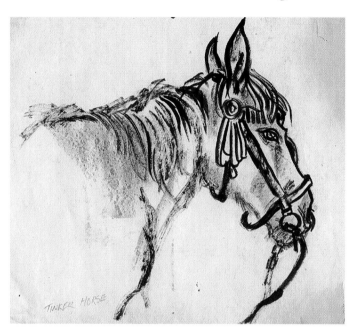

On the ground near him was a half-made tin cup. He had cut a long piece of tin for the handle, turned the ends over and was now hammering them flat on an iron anvil which rested between his knees. I watched as he gently shaped a curve and then taking the red-hot poker from the fire he neatly soldered the handle onto the cup. He told me that he made cans, saucepans, tall teapots, buckets, basins and mugs of all sizes. His father and grandfather had been tinsmiths and their designs had been handed down to him. Their wares had been sold at fairs and farms down the years. However, it was now a dying trade and he said he would soon have to turn his hand to other skills if he wanted to make a living.

The day had flown by and as I prepared to make my way home Liam, who had been sitting with Clarence, approached me and asked to see my drawings. He told me that he taught an amateur art class in Lower Springfield once a week and asked if I would be willing to help him with it. I was bemused at

Sketchbook drawings, 1947

the idea of teaching other people to draw since it seemed such a short time since I had been pumping other artists for help myself. I agreed, thinking that I might be glad of the company of like-minded companions in the long winter evenings to come.

Over the next few weeks I spent many hours at the tinker encampment and produced more than fifty black and white drawings, fifteen small watercolours and finished two oils. One of the oils, that of a dark-haired tinker girl, I thought to be my best painting ever.

One Saturday afternoon Arthur Campbell turned up at the camp armed with his camera. Arthur was a photographer of considerable talent and he produced some wonderful images of the tinkers. Some of them he turned into watercolours which he exhibited at our joint show the following January.

Although I missed the BBC programme Liam had been successful in getting the tinkers and Clarence their moment of glory.

One morning I turned up at the camp to find that the tinkers were on the move again. I stood watching as the ponies dug their hooves into the uneven grassy hillside, taking the strain of loaded caravans as the clan filed slowly out onto the Springfield Road, making for the open country-side and beyond. Clarence was the last to emerge and catching sight of me he swung his hat in the air and waved in farewell.

Drawing from
James's sketchbook, 1947

We had set the date of our first group exhibition for 19 January 1948. The venue was the function room of the Country Tea House at number 55a Donegall Place which had a separate entrance from the restaurant. The long narrow room was at the top of a long flight of stairs and, in time, became generally known in the artistic community simply as 55a. I think our group was probably the first to hold an exhibition there.

Taking part in the exhibition were Arthur Armstrong, Arthur and George Campbell, Aaron McAfee, Gladys and Max MacCabe, Tom McCreanor, Daniel O'Neill and myself. We had agreed to contribute five pounds each towards the expense of mounting the exhibition, so anyone failing to sell would be out of pocket.

From the outset George took command of the venture and his manic energy drove some members of the group to distraction while others contrived to ignore him. We were organised like troops. He ordered us to write notes on our paintings for the catalogue, list titles and prices and each of us was to ensure that our own paintings were well framed. Woe betide anyone who fell down on his deadlines.

He worried that the exhibition would not get enough publicity and demanded that we each produce a poster advertising it. Two days before the opening we were instructed to meet him in town, each of us bringing our

ART IN ULSTER

an exhibition
by nine painters

in the gallery
55a Donegall Place, Belfast
January 19—31, 1948

Opening at 3 p.m. on January 19
by the Rt. Hon. the Lord Mayor,
Alderman W. F. Neill, J.P., M.P.

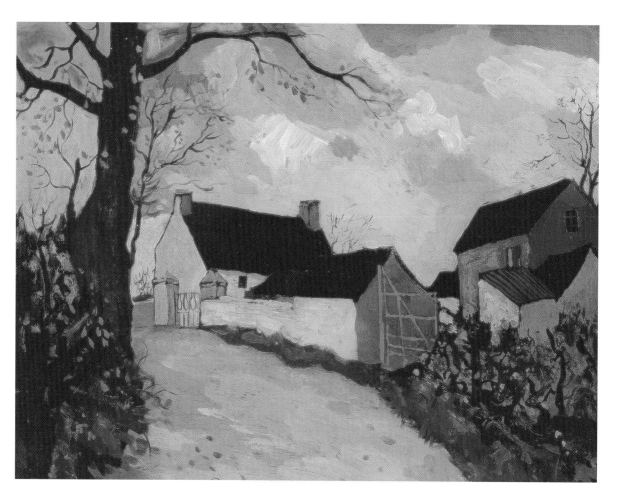

Country road, 1947

poster. I arrived first and found George waiting with a bucket of paste and a brush at his feet. He was swinging his arms around, hopping from foot to foot against the cold, and grumbling about everyone being late. In the end everybody but Dan turned up. I learnt later that Dan had been heard making some very caustic remarks about George and his posters.

When we were all assembled George commanded us to follow him as he set off with his bucket and brush in a quest for suitable walls on which to paste our posters. There was much discontented muttering as we skulked along the shadowy streets stopping every now and then to hurriedly stick up a poster and, at the same time, doing our best to ignore the stares from suspicious passers-by. Next morning some of us toured the poster sites only to discover that heavy overnight rain had reduced the lettering on most of them to an undecipherable smudge.

By three o'clock on the 19 January the 55a Gallery was hung with our perfectly framed paintings, catalogues were stacked in neat piles on a table, reporters and press photographers were gathered ready to record the opening ceremony and we artists were huddled together trying to look as nonchalant as possible. Before quite a large crowd and after a rather long speech, the Lord Mayor of Belfast, Alderman W.F. Neill, duly declared the exhibition open to the public.

Things were ticking along nicely when there was a sudden altercation at one

end of the gallery. Langtry Lynas was an artist of an older generation and there he stood, his tiny frame swathed in a massive woollen cape and a broad brimmed hat on his head, holding forth vociferously on the decadent state of Ulster art. Prime examples of this decadence he declared were hanging for all to see on these walls and he waved his walking stick at the offending paintings.

He was eventually and not without difficulty ushered out through the glass panelled door which, in his umbrage, he banged shut behind him with such force that some of the said examples of decadence quivered on their hangers. This was the first of many similar encounters with Langtry Lynas that would take place over the next few years. When the gallery closed at six o'clock that evening ten paintings had been sold. One of Dan's oils entitled 'Jessica' went for twenty-five pounds. This set George to grinding his teeth in resentful ire. He had not sold anything and nor had I.

Afterwards we all went to Campbell's for sandwiches and then to the Duke of York bar in Commercial Court for a few drinks. We were all in a state of excited anticipation at the thought of seeing ourselves in the following day's newspapers.

Around eight o'clock a group of French sailors entered the bar and I noticed them in conversation with Dan. Then some of the local pressmen turned up and George abruptly left our group and made a beeline for them. A couple of hours later as the crowded pub was humming with animated conversations and thick with the smoke of endless cigarettes, I decided that I had had enough for one day and decided to leave. I had to be up early next morning as I had been deputed to look after the gallery for the day. The night air was stingingly cold

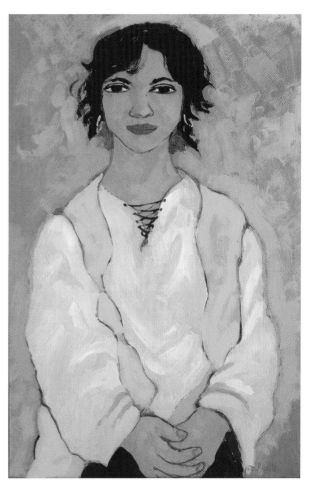

Tinker girl, 1947

after the warmth of the pub as I trudged up the hilly Shankill Road. The house was dark and silent when I let myself in and the family long since tucked up in their beds. Da was on the early beat and ma always got up to make his breakfast.

Next morning I opened the gallery on time and after about ten minutes the door was flung open to admit a tall middle-aged man with flowing hair. He didn't trouble to close the door behind him and ignoring my presence he strode round the gallery a few times before finally stopping before my painting of the tinker girl. Pointing at it he addressed me in a strong mid-European accent asking who had painted it and also how much it cost. I stifled the urge to tell him that if he spent sixpence on a catalogue he would find out. Instead

I told him that the painting was one of mine and that the price was twelve guineas.

He looked me in the eye and said, 'I'll give you twelve pounds for it.'

I thought about it for a few seconds before answering, as the twelve shillings difference would buy quite a few tubes of paint, but twelve pounds was not to be sneezed at and so I agreed to the reduced price. Immediately he asked if I had a working drawing of the painting and thinking I might make another sale I told him that I had. He seemed pleased at this and just as I was working out how much to charge for the drawing he told me he would like it thrown in as part of the sale. I seethed. Compared to me this man was probably as rich as Croesus and here he was haggling over a few shillings. I figured that if I didn't let him have the drawing he might renege on the whole deal and so very reluctantly I agreed to his terms.

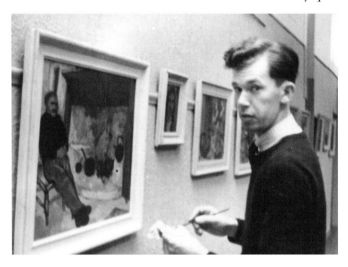

James at Donegall Street Gallery, 1948

'Good. I like it! It's a beautiful painting,' he said.

He went round the gallery another few times stopping briefly to look at some of the paintings then, handing me a business card, he told me that he would collect and pay for the picture on the last day of the exhibition. When he had gone I looked at the card. His name was Zoltan Lewinter Frankl and he was one of Ulster's best known art collectors.

A while later a group of people arrived, bought some catalogues, and slowly and with much chattering worked their way around the exhibition. Then one of the ladies, who was wearing an enormous pearl necklace, approached me and asked if she could buy the big O'Neill still life. I was delighted at having made another sale so quickly and when she asked for Dan's address as she had a commission in mind which might be of interest to him I gave it to her. She paid twenty-five pounds for the painting and said that someone would collect it for her.

The group was still in the gallery when George came in and sidling over to me he asked out of the side of his mouth if anything interesting was happening. I gave him a rundown on the sales so far. As we were speaking the visitors departed saying how much they had enjoyed the show. The door had hardly closed behind them when George went berserk. He jigged down the long room brandishing a rolled up newspaper in the air and, stopping before Dan's still-life, he proceeded to use the newspaper to beat out a tattoo on the ornamental frame all the while uttering a stream of invective. I just stood and gawked. He was in full flood when the door opened quietly and a very fragile looking Dan lumbered in. From the corner of his eye George registered Dan's presence and without a word to either of us he was through the door

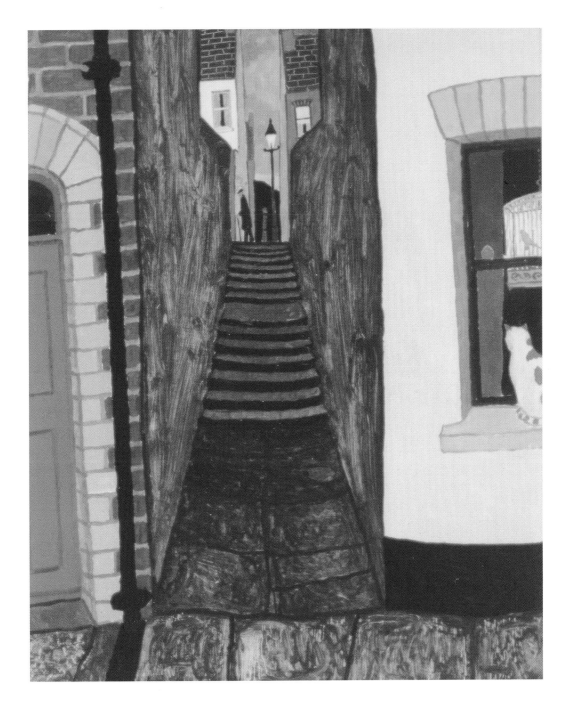

and down the stairs as fast as a whippet chasing a rabbit.

Passageway,
1948

Dan, however, didn't seem to have noticed George's antics for he just asked mildly, 'What's biting him?'

Dan really did look terrible. He was as pale as whitewash and seemed to be half asleep on his feet. Without even a mention as to how things were going with the exhibition he slumped down on a chair and started to tell me what he could remember of his adventures of the the night before.

It seemed that after the pub had closed his newly found friends, the French seamen, had invited him to join them for a drink aboard their ship which was anchored at the docks. He followed them on board and after a few hours of

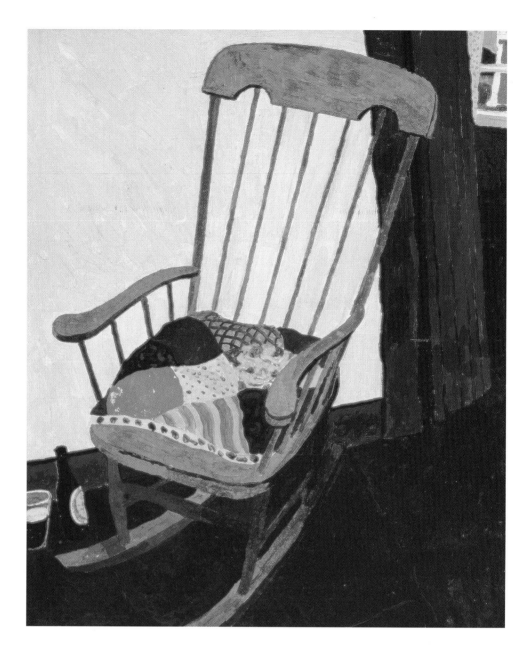

Rocking chair, 1948

boozy conversation he must have dozed off. When he surfaced briefly later he was vaguely aware of a rhythmic droning. He drifted off to sleep again and the next thing he remembered was being jolted awake by the sound of a sonorous wail from somewhere above his head. He was just going under again when the realisation of what he had heard finally penetrated his fuddled brain and he sat up, feeling his head ache and his stomach turn over as he did so. Dan was still on board the ship but the ship was not anchored at the docks any more; it was halfway down Belfast Lough and the sounds he had heard were the ship's engines and the foghorn!

He very soon he found himself being interviewed by an irate captain who, in a deluge of heavily accented English peppered with French profanities, accused him of being a stowaway. With the help of his erstwhile sailor friends the situation was eventually resolved and the captain, still muttering asides,

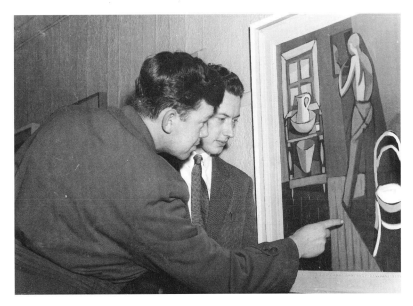

James with Arthur
Armstrong at the Donegall
Street Gallery, 1948

radioed a request for Dan's transportation onto dry land. By this time the ship was at the mouth of the lough and to Dan's consternation he heard that it was bound for Marseilles. Luckily there was a pilot boat in the area and amid the darkness and the surging waters it hove alongside. With the help of a powerful lamp and a tether around his chest in case he fell off, Dan eased himself carefully down a rope ladder suspended from the ship's side, to land in a heap on the deck of the undulating pilot boat.

When, at length, he disembarked from the pilot boat he was promptly collared by the Harbour Police who grilled him for an hour and finally released him with a caution.

When he had finished his tale Dan, still sprawled in the chair, was quiet for a bit and then heaving himself unsteadily to his feet he announced that he was off home to sleep for a week. It crossed my mind that his wife, Eileen, might take a bit of a dim view of his escapade. As he staggered through the door and down the stairs I yelled after him that another of his paintings had been sold. Without turning his head he raised a hand in acknowledgement and went on his way.

When the exhibition finally closed we agreed that it had been a moderate success and everyone had sold at least one painting. To everyone's relief George had sold two oils and consequently was feeling more kindly disposed towards the world again.

On the day before the exhibition ended I had a note from Lewinter Frankl telling me that he would be unable to collect his painting and would I deliver it on Monday morning at his office in Newtownards. With a considerable amount of trouble I lugged the picture there by bus and presented myself at his office. He kept me waiting for

County Antrim coast, 1948

ten minutes before he put in an appearance and when he did he checked that the drawing was in the parcel before giving me a cheque for twelve pounds. I found myself out on the road again within a few minutes and was not pleased to discover that I had missed the bus back to Belfast and would have a long wait for the next one.

When later I went to the bank to cash the cheque I was asked for identification. I had none on me so the cashier refused to cash it. I asked to see the manager, a pompous individual, who gave me more of the same waffle. After some more wrangling and in total exasperation I told him that I was going to phone Frankl and tell him that the bank would not honour his cheque and that I would be going back to Newtownards to repossess the painting. They cashed the cheque.

Sometime later I found out that Lewinter Frankl actually lived in Belfast. I was furious and incredulous that I had been asked to spend time and money going all the way to Newtownards just to indulge his fancy. I could only suppose that in some way it added to his sense of self-importance that he thought he could manipulate people in this way. I almost felt sorry for him.

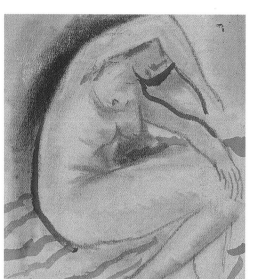

Nude, 1948

One day, as I was doing my stint as minder at our show in 55a, Renee Bickerstaff, a painter whom I had got to know through the Artists International Association, had come puffing up the stairs and sat herself down beside me for a chat. In the course of our converstation she had suggested that I ought to join the life classes run by the Ulster Academy in the old museum building in College Square.

Nude, 1948

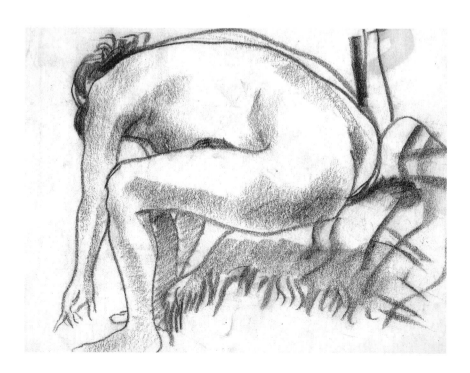

That was how, one evening a few weeks later, I came to be sitting in a circle of about twenty people who were grouped round a dais on which languished, in a suitably artistic pose, the figure of a nude female model. To say that I was abashed was to put it very mildly. My pencils, sharpened to pristine points, lay unused as in turn I leafed unseeingly through my sketchbook, examined my shoes and tried to memorise every knot on the old stained floorboards beneath my feet. In short I found myself looking every-where but at the model.

Beside me sat old Tom Curley. A battered trilby was jammed on his head and ancient wire-framed spectacles rested on a bulbous nose that teemed with tiny crimson veins. From one of the pockets of his long black overcoat dangled, unappetisingly, a grubby handkerchief. The lower part of his coat, his trousers and his shoes were enveloped in a liberal dusting of multicoloured pastel dust. As a result of the dust, every few moments he would grab the handker-chief and snort into it with such force that his trilby was shunted over one eye.

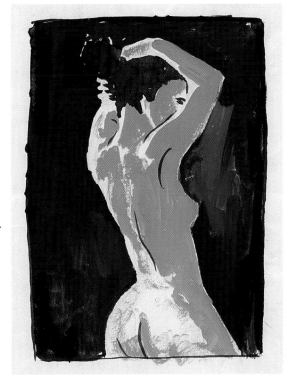

Nude, 1948

Tom had been watching my discomfiture for some time and with a gleam in his eye he leant towards me and said, 'Just concentrate on the head and draw downwards.'

I tried this approach but was distracted when my eyes locked with those of the model and it seemed to me that she gave me a knowing little smile. Then I took Tom's advice in reverse and starting at the feet I drew upwards. This seemed to work and it was not long before I became so engrossed in the technical complexities of the drawing that I forgot my blushes and was able to concentrate solely on producing a good drawing regardless of the subject matter.

After some time I had finished four drawings and Tom, raising his bushy eye-brows remarked, 'I see you're settling in.'

When the session was over Renee introduced me to the model who was now mercifully wearing a long blue dressing gown. We sat talking for a time and she told me of some of her experiences as a model at the College of Art. In particular she recalled one young man who had passed out at the sight of her unclad form and had to be manhandled out into the corridor by some of his fellow students where they propped him up in a chair and attempted to revive him.

'It's not often students swoon at my feet,' she said.

After my initial reservations I came to enjoy the life class and the company of my classmates and we would spend lots of time discussing different styles of painting and subject matter. In the Belfast of the 1940s, art exhibitons were rare events. Most of the people at the life class knew that I had taken part in

the exhibition at 55a and they applauded our group's initiative in organising it.

At first I took care to keep my nude drawings well away from ma's gimlet eye, but eventually I showed them to her and at the same time explained the purpose of the life class. She looked at them for a while then turned and picked up her knitting.

'Shameless hussy that one!' was her only comment.

In the collection of the Ulster Museum is an oil painting of a semi-nude woman in a blue skirt against a background of houses and trees. It was painted by Dan and was originally commissioned by the woman who bought his still life from our group show. She had seen his work at the Waddington Gallery and had been impressed and then, by chance, she happened to be in Belfast at the time of the exhibition. In view of subsequent events Dan never would tell us the lady's name but he did say that she was very wealthy and lived in a big house near Galway town.

The lady had contacted him and asked if he would be willing to make an all expenses paid visit to her home in order to paint her. Never one to turn down a lucrative offer, especially if a good-looking woman was involved, Dan did not hesitate to accept the commission and off he went. He was met at the railway station in Galway and driven to the big house by a local who engaged him in a conversation that was blatantly designed to elicit from him the reason for his visit. Dan, of course, told him nothing.

When they arrived at the gates of the house he was ferried past a lodge and up a long driveway bordered with well cared for lawns and shrubs and deposited at the door of a large square house. His hostess was waiting on the step to greet him. Later on, over the evening meal, she told Dan that her husband had been unexpectedly called away on business and afterwards suggested that they should take a walk so that Dan could get an impression of the local countryside. As they strolled along in the summer evening the lady explained to Dan that she would like him to paint a half-length nude portrait of herself using the house and the local landscape as a backdrop.

The following day, Dan occupied himself by doing a series of sketches of the house and grounds from various angles. In the evening after a late dinner, accompanied by a decanter of red wine followed by not a few brandies, his hostess suggested that he might like to make some preliminary drawings of her. Of course, one thing led to another and later on that evening Dan was shaken awake by the lady trying frantically to haul him out of her bed. Her husband had come home. In a panic she pushed the befuddled Dan into a large wardrobe and banged the door shut. Her cat, which had also been snoozing on the bed, sprang off and landed on the floor with an snarl of indignation. Holed up in the wardrobe with the sweat rolling off him, Dan listened as the husband entered the room and after a few words with his wife, complained that he was tired and was going to take a shower. At that moment the cat decided that it fancied the sanctuary

PAINTERS

an exhibition in the gallery
55a Donegall Place, Belfast
October 18 - 30, 1948

**10 a.m.—6 p.m. daily
including Saturdays**

Opening at 2 p.m.
on Monday, October 18
by Dr. J Stuart Hawnt

Admission by catalogue sixpence

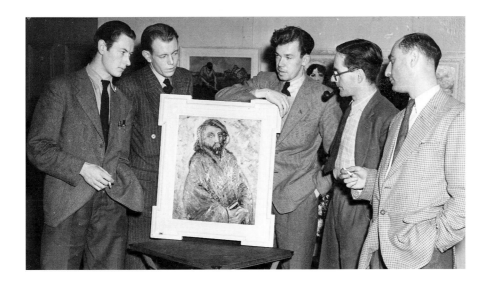

James (centre) with (from left),
Arthur Armstrong, Tom
McCreanor, Arthur Campbell
and Leslie Zukor

of the wardrobe and, to Dan's consternation, began to scratch and paw on the door. Panic was really taking hold as Dan heard the husband wondering aloud what was wrong with 'that bloody animal'. To his relief he heard the lady tell her husband to go and have his shower and she would take the cat downstairs. After this things went quiet for a bit and Dan was left not knowing whether one or both of them was still in the room. After an agonising time the wardrobe door was unlocked and the lady, with a finger to her lips, beckoned Dan out and told him to gather his belongings and remove himself to the lodge. It then transpired that this was where he had been intended to stay all along.

Clutching his bags and the key to the lodge, a dazed Dan found himself negotiating his way around shrubbery and outhouses in the dark. Suddenly there was the sound of an upstairs window being banged open, a great deal of loud swearing and two gunshots. By this time, completely terrified and almost sober, Dan gave up any idea staying in the lodge and instead got himself out of the grounds and onto the main road as fast as his palpitating heart and trembling legs would allow. He made it the three miles or so to the railway station where he spent the night on a bench in the waiting room before catching the first train to Dublin next morning.

A few weeks later a letter addressed to Dan was forwarded by the Waddington Gallery. It was from the lady in Galway apologising for the untimely arrival of her husband

Line drawing of two girls, 1949

and the subsequent fiasco. Then she casually mentioned that just after Dan had left the house her husband had spotted from the bathroom window a couple of foxes frolicking on the lawn and had discharged both barrels of his shotgun at them. She ended the letter by suggesting that perhaps she and Dan could arrange another meeting.

Dan's response was predictable. 'Not bloody likely!'

He did, however, complete the painting after altering the background and the sitter's features. It was bought by the Ulster Museum in 1949.

Les Enfants du Paradis was a French film about a troupe of circus artistes and the clown in it was played by the mime actor Marcel Marceau. George saw it first and was captivated. He positively drooled over it, so much so that the rest of us thought we must be missing something special and we all went along to see it, accompanied by an ecstatic George. We enjoyed it immensely but were not fascinated to the extent that George was for soon afterwards he produced three small oils of which I saw only one. It was of a clown in a white costume with the head in profile, tilted down towards a raised shoulder. The colours were in sombre blues, greys, white and black and to me it looked a bit dismal.

For some time George had been nagging us about mounting another exhibition and eventually we agreed on a date in October, 1948. We thought that in October we might capture the interest of a few early Christmas shoppers. Our group, reduced to six for this exhibition, consisted of Arthur Armstrong, Arthur Campbell, George Campbell, Tom McCreanor, Leslie Zukor and myself. Dan O'Neill did not take part this time as he was busy getting ready for a second exhibition at the Waddington Gallery.

October loomed and the rush began to frame our paintings. One day George and I were in Mol's framing shop when the door swung open and in sauntered Dan with a clutch of paintings under one arm. He seemed a bit

Conversation, 1949

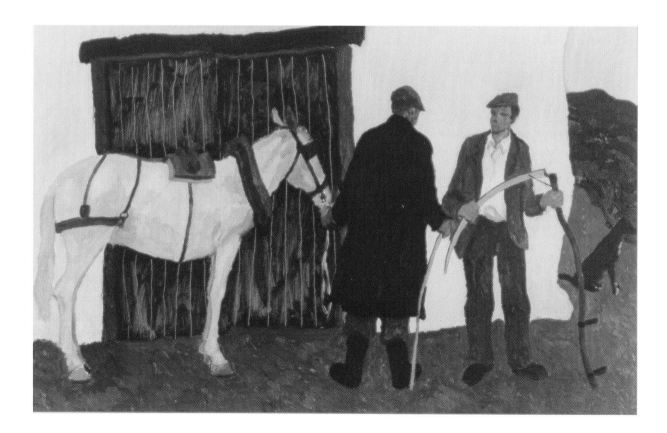

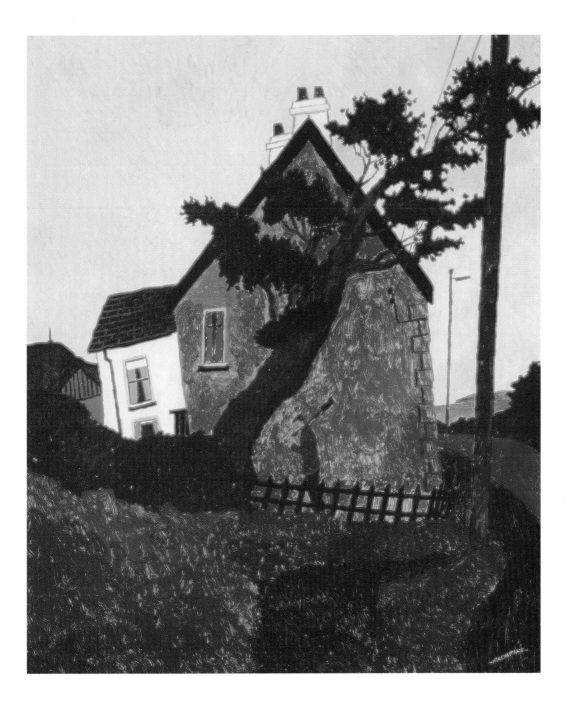

more taciturn than usual and I wondered briefly if he had been lifting his bar arm the previous evening. In one of the tense silences between cursory bouts of conversation, Mr Mol quickly began to wrap up the last of George's paintings, which happened to be the one of the clown. Dan fixed his eye upon it for a moment and then addressed George.

'Campbell,' he said slowly and deliberately, 'how can you be so pathetic?'

George had just taken a deep draw on his cigarette and his mouth slacked open in bewilderment. Smoke trailed away and drifted in little eddies around his head. For long minutes Dan and he stared hard at each other and then George swung on his heel, brushing deliberately against Dan, paid Mr Mol

and, picking up his paintings, he stalked out of the shop without a word. Mr Mol, plainly embarrassed, busied himself tidying something beneath the counter. Dan looked at me and said with elaborate unconcern, 'He's a bit crotchety today!'

The nail-biting strain of waiting for sales to cover our gallery expenses was greatly eased when the Council for the Encourgement of Music and the Arts agreed to pay the rent of the gallery. The opening ceremony was performed by Dr J. Stewart Hawnt on 18 October 1948. Only minutes before Dr Hawnt stoood up to speak George had grimly ushered Langtry Lynas, protesting loudly about hooligans holding exhibitions and a gullible public parting with its money, down the stairs and out onto the street.

There was a large turnout of people and sales were much better than at our previous exhibition. Someone had conceived the idea of mounting drawings in a large folder and selling them unframed for between ten shillings and one pound. This proved quite a lucrative venture for some of us, including myself.

From left to right: Arthur Armstrong, James and Tom McCreanor at the Donegall Street Gallery, 1949

At the close of the exhibition we had sold twenty of the fifty-two paintings on the walls as well as seventeen drawings. My paintings and drawings were bought by John Hewitt, Raymond Piper, Charles Brett and a Miss Orr from Ballycarry who, in times to come, would buy often from me. George's painting of the clown didn't appear in the exhibiton and I never did have the courage to ask him why. I know that after the incident in Mol's shop things between Dan and George were never the same again and Dan gradually drifted away from us.

It was at about this time that Tom McCreanor, Arthur Armstrong and Arthur Campbell were seriously considering giving up their well-paid jobs to pursue art full-time. The year before I had thrown away my spanners and so far I had just scraped by without plundering my savings. I had not regretted my choice and felt that my paintings and drawings had benefitted from the extra energy I now had. Even more importantly, my parents had just let me get on with things and never interferred in my affairs.

Things were different for Arthur Armstrong. He lived with his widowed mother, younger brother and sister and although not the only breadwinner in the house he was certainly the best paid one. However, having made his decision and without telling his mother, he left his job with enough money saved to last for nine months. Every morning he would leave his house ostensibly to go to work but, in reality, he spent the whole day painting in the back attic room next to my studio. I had somehow prevailed upon ma to allow him the use of the room. Needless to say I did not tell her that his mother knew nothing of what was going on. He and I worked quite happily in proximity. We

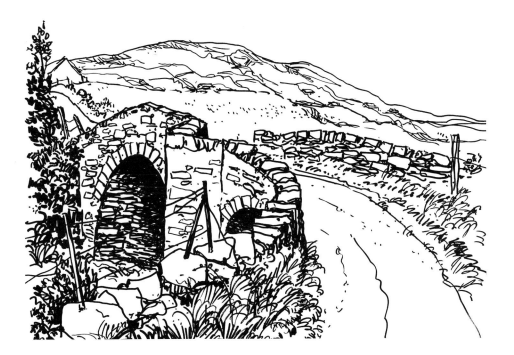

rarely discussed our work and certainly while it was in progresss we each kept Glencolumbkille, 1950
to our own space.

Arthur tended to work slowly and was not a prolific painter so this combined with a dearth of sales meant that, just under a year later, his savings had run out and he was forced to look for a job. He found one as a damask designer for Ulster Laces in Portadown which, taking into account the time spent in travelling there by rail, meant that he had a twelve-hour working day after which he would spend the evenings trying to paint as much as possible. Inevitably his health was affected and later it was discovered that he had symptoms of early tuberculosis and for a time he had to take life very easy.

Arthur Campbell was an exceptionally talented watercolourist but he too worked very slowly and had a low output of paintings. With his former connections in the advertising world he did manage to secure a certain amount of graphic design work and at one period he and I worked successfully together on fabric designs for the Flaxalls Company at Carrickfergus.

Arthur lived with his mother in Magdala Street and in the early 1950s his finances became so precarious that he was forced to take a job in Manchester and I, personally, was very unhappy to see him leave. He stayed in Manchester for about nine months and then returned to Belfast when he got a job as advertising manager for Thompson Reid, the car dealers. Once home and settled he began to paint again.

In 1949, Tom McCreanor also faced a dwindling money box but he solved his problem by acquiring a very nice summer job as warden at the Bloody Bridge Youth Hostel, near Newcastle, in County Down. For the next couple of summers on my visits to Bloody Bridge, Tom and I were to spend many happy and productive hours on drawing expeditions. We sketched and painted on the slopes of Slieve Donard and on occasions scrambled to its summit

to take in the magnificent panorama.

The basic problem for all of us in selling our work was the lack of art galleries. At this date no outlets other than Rodman's and Magee's existed and we were mostly dependent for sales on our group shows.

Illustration of a pheasant for the *Larne Times*

In those days I used to spread myself in various directions in attempts to make some money. I painted posters and showcards for shop windows, designed Christmas cards which I sold to the local shopkeepers and produced illustrations for weekly nature study articles which ran in the *Larne Times* for about three months. One assignment which I really enjoyed doing was at the Lyceum Picture House on the Antrim Road. Inside the foyer, well above the double doors that led to the auditorium was a ten foot long, crescent-shaped mural depicting some obscure Italian town perched on the obligatory hill top. By the time I saw it, it had practically disappeared under a muddy-brown fog of filth, caused by exposure to years of smoke and dust. My brief was to resurrect it so I set to cleaning it with lukewarm water and removed the grime one foot at a time. This done I retouched the most badly damaged areas and finally varnished the whole thing. The colours came up beautifully and shone as bright as a new sixpence and the management was delighted with the transformation. It had taken me about ten days working between performances and I was paid a handsome twenty-five pounds for my efforts. For months afterwards I hauled various friends and family to the Lyceum just to look at it.

Lyceum Picture House

Another commission came from an old lady who lived near us. She turned up one day with six old family photographs and asked me if I would do some portraits from them. The monochrome prints showed her bewhiskered and bonneted relatives dressed in what I considered to be the the weirdest of Victorian fashion and I toiled to copy them in a mixture of pencil, charcoal and ink. When I had finished I had the drawings framed in oval mounts and the old lady was so delighted with them that, to my embarrassment, I was invited to tea to talk about her ancestors.

In November 1950 George announced to everyone in Campbell's Restaurant that he was fed up with Belfast where artists were not appreciated and that he and Madge, his wife, were moving to Dublin.

Some time later I met Gerard in Royal Avenue. He was on one of his flying visits to Belfast. Over a coffee in Campbell's I filled him in on all the latest happenings at home and he in turn told me of his experiences in London. Life was not always easy for him, plagued as he was by a chronic shortage of cash. Luckily his sister Mollie, his landlady, never pushed him for the rent, knowing that it would come when he had the money.

He asked about Dan and said that someone he knew had encountered him in a pub in Dublin and that, as usual, he had been drunk. Before we parted he told me that next year he might be going to the west of Ireland for a long stay as he had struck a deal with a London friend who owned a cottage in Connemara. It all depended on his finances he said.

'Write to me,' he shouted over his shoulder as he ran for a tram.

Haystacks, County Antrim, 1949

Whitehead lighthouse
1951

8

It had crossed my mind more than once to approach Magee's Gallery with some paintings, but as John Magee had shown little inclination to exhibit either Dan's or Gerard's work, I doubted if mine would interest him either. Then on an impulse I decided to try my luck. I had nothing to lose.

When I arrived Magee ushered me upstairs where, taking my paintings from me, he propped them on the floor to examine them. After a while and with much humphing and clearing of his throat he asked me what my asking prices were. I told him.

'Write the titles on the back and come back in a month,' he said.

As I was scribbling hastily composed titles on the paintings he told me to be aware that his gallery would take one third of my quoted price. I nodded in agreement and stood up. He tucked a painting under each arm and walked away.

I was perplexed at Magee's acceptance of my paintings. Perhaps, I thought, he had read the art critics' favourable reviews of my work, or maybe news of the wide acclaim and high prices paid by the Dublin public for the work of the Ulster artists he had rejected, had reached him. Either way I had a smile on my face.

Later that evening I strolled the couple of miles to Arthur Armstrong's house in Churchill Street off the Antrim Road. I found him looking even more wan

Whitehead village, 1950

than usual and just about to accompany the family mongrel on her evening outing. As we followed the dog on its long lead I told Arthur about my experience with John Magee and he, deadpan as usual, suggested that perhaps Magee was testing the water before promoting any serious art.

We were distracted from our musings by the dog whose usual habit, much to Arthur's irritation, was to sit down on the tramlines to empty her bladder. This time, however, she decided that she would go the whole hog and proceeded to drop pancakes all over the tracks. In the near distance we could see a tram approaching and Arthur began to make frantic efforts to haul the dog to safety. As he tugged, the obdurate hound slid along on her backside, leaving behind a little row of elongated pyramids. She cleared the tracks just in time as the tram hurtled past with the driver jangling the bell and shaking his fist at us.

'Bloody dog,' panted Arthur. 'She's going to get us both flattened some night.'

Sketch of the writer, Tom Skelton, 1951

One morning I dropped into Smithfield Market to have a poke through the junk stalls in search of old frames which I could refurbish. I heard someone call my name and looking round I saw Olive Henry standing among a pile of second-hand books.

Olive worked as a stained glass designer for Clokey's in Castle Street and after asking me how things were going on the financial front she mentioned that there was a vacancy for an assistant stained glass designer with her firm. She wondered if I would be interested in applying for it and she told me to think about it and to call at her office the following day if I was.

I was in a bit of a quandary. If I needed to return to regular work then the job at Clokey's would be ideal, but on the other hand, I had the feeling that this would be like giving up before I had run the course.

Nevertheless, next day I presented myself at Olive's office and was given a sheet of paper, five feet long and eighteen inches wide, together with a black and white cartoon and instructions to make a copy of it within a week. Three days later I returned with the finished artwork and handed it over to Olive. She complimented me on it and told me that there were four other applicants for the job and we arranged an interview.

On the day of the interview I arrived ten minutes early to find a young girl already there. We got talking and she told me, as she sat nervously twisting her fingers, that she was one of the other four applicants for the job and that they were all graduates of the art college.

When my turn for interview came I found Olive and Mr Clokey sitting behind a long desk on which was laid my copy of the cartoon. After some minutes watching and listening to Mr Clokey, I came to the conclusion that he reminded me strongly of my old headmaster, Isaac Abraham – a man completely in charge and accustomed to having his own way. He asked all the usual questions about my background and experience and seemed surprised that I was self-taught. His eyebrows inched upwards when he heard that I had abandoned my last job for a career in art.

When we came to the subject of salary I was told that, if offered the job, I would be paid two pounds a week which would rise by annual increments. I looked at him. This was fifteen shillings less than I had earned in my final week as an apprentice at Coulter's. I told him that this was not enough and, with a sideways glance at Olive, who had remained sitting silently with her hands hidden beneath the polished desktop, he said that two pounds and five shillings a week was his final offer. I refused it. He grimaced and immediately began shuffling his papers together and stacking them neatly on one side, an obvious signal that the interview was at an end. Then I asked if I could have my cartoon back. He looked at me in disbelief.

'Certainly not,' he said indignantly. 'That is our design and is the property of the firm.'

I pointed out that I had spent two days working on it, time which might have been spent more profitably. I asked him why he could not have judged my abilities from a look at my portfolio instead of asking me to spend long

Staircase, 1951

hours copying out his design. By this time his face had turned crimson, and spluttering with outrage, he repeated that the artwork was his firm's property and that I could not have it back.

At this I lost the bap and, rising slowly to my feet I reached across the desk, lifted the cartoon shoulder-high and ripped it in two down the middle. If I couldn't have it then neither would he.

Turning to Olive I gave her a nod and, as I walked away, I could have sworn that lurking beneath her huge spectacles was the ghost of a twinkle.

By March 1951 the state of my finances was as dire as ever but, encouraged by some critical acclaim in the local press and reasoning that I had nothing to lose, I made a provisional booking for a one-man exhibition at 55a Donegall Place. I calculated that I would probably need something like fifty paintings to fill the gallery.

Friend of James,
Sean MacKay, 1951

I had recently met Paddy McMechan, a young artist who had trained in Dublin. Paddy was red haired and ebullient and did not seem to suffer from the chronic shortage of cash that afflicted the rest of us. One day he asked me if I would like to go with him to Armagh for a day's sketching and, with the need to produce a lot of new work always at the forefront of my mind, I accepted the invitation.

The following Sunday found us careering through the Ulster countryside in Paddy's car complete with a hamper of grub in the back seat. We parked near the Mall in Armagh and made a tour of the city. I was much attracted by some of the back lanes and spent some time drawing the little houses with their higgledy-piggledy backyard walls, inset with brightly painted doors.

Later, after we had demolished the contents of the hamper, we drove out of Armagh and found ourselves at a crossroads where a stack of bicyles lay abandoned in the ditches. Down one fork of the road we saw a crowd of men milling about and as we approached we thought we had stumbled upon a funeral. This idea was soon dispelled by a great roar from the crowd as over their heads we glimpsed a whirling arm and then heard another roar. When the din had subsided Paddy stuck his head out of the car window and asked an old boy what was going on.

It turned out that it was a game of road bowls and the old fellow took great pleasure in excitedly explaining the sport to us. He told us that it was played with a solid iron ball weighing twenty-eight ounces which was thrown along the road for a distance of about three miles. The contest was between two players and whoever reached the winning mark in the least number of throws, won

Whiteabbey, 1950

the game. By this time we were both out of the car and as Paddy mingled with the crowd I lagged behind to make pencil notes of the throwers in action and the jubilant antics of the spectators when the game went their way. In the midst of all the hullabaloo I noticed some figures huddled together with hands dug deep into trouser pockets, fishing out betting money.

After a long and very enjoyable day we made our way home via a round-about tour of the countryside. I was very pleased with myself for I had completed more than a dozen sketches and I itched to get started on turning them into paintings.

About three months later John Hewitt bought from me a small oil painting of one of the back lanes in Armagh and years later it was used in a publication called Art in Ulster which was edited by John Hewitt and Theo Snoddy.

One morning in April 1951 I heard the clang of the letter box in the hall as a letter slid through. It was postmarked Galway and was addressed to me and instantly I recognised Gerard's handwriting. Bursting with curiosity I opened it and, to my amazement, read that he was living on an island called Inislacken which lay off the coast of Roundstone in Connemara. He wanted me to come

and join him there. 'Stone walls, thatched cottages, a real peasant life. Just up your street!' eulogised Gerard and ended prosaically by listing a set of oil colours which he wanted me to bring along.

I have always been fascinated by islands and the thought of this one, located in the Atlantic, set my juices flowing. But such was the state of my finances that the chances of my ever getting there seemed pretty remote. I got out an atlas and looked for Roundstone and found that it was just north-west of Galway town. This meant that I would have to get the train from Belfast to Dublin and probably spend a night there before catching another train to Galway. Pigs might fly!

For the next couple of weeks I could not get the image of Gerard's island out of my head. Finally, and more out of desperation than anything else, I took myself to Magee's Gallery to ask if by any lucky chance they had managed to shift any of the paintings I had left with them.

The assistant looked at me for a minute and then said that she would check. She motioned me to take a seat in the upper gallery and there I sat for nearly

Back lane, Greenisland, winter, 1951

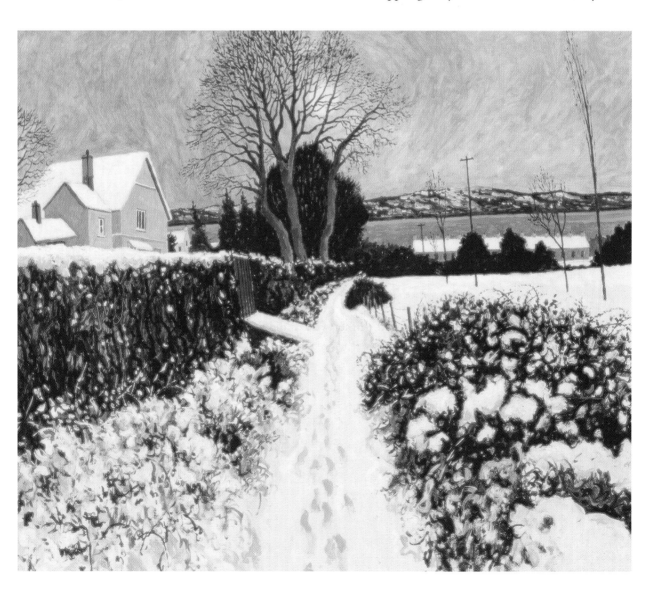

Back lane, Greenisland,
summer, 1951

half an hour, watching her increasingly agitated progress from gallery to store-room to office, with never so much as a glance in my direction. Eventually a grim-faced John Magee himself appeared, clutching a handful of notes which he thrust reluctantly at me.

'Here's seventeen pounds,' he said glumly and asked me to sign for them.

I never did find out exactly what had happened to my paintings. They might have been lost among the jumble of Magee's storeroom or perhaps they had been sold and the invoices misplaced. Either way I didn't care. Seventeen pounds was a fortune to me and more than enough to fund my trip to Connemara and Inislacken.

A week or so later, having in the meantime written to George in Dublin to cadge a bed for the night and with ma's admonitions about taking care of myself still ringing in my ears, I set off on my great adventure.

To my surprise and pleasure I found that when I got to George and Madge's place George had decided to come to the west with me. And so it was that in the late afternoon of the next day, we found ourselves bone-weary, crawling off the bus in the main street in Roundstone. Gerard, arrayed in an Aran

sweater with a colourful crois holding up his baggy trousers, a pair of hobnail boots and his duncher pushed to the back of his head, was waiting for us. He introduced us to his friend, Michael Woods, who had been leaning against a pub door and explained that Michael lived on the island and would row us over in his curragh.

Two hours and more than a few pints later we stood at the harbour watching as Michael hauled the curragh, attached by a long rope, closer to the steps so that we could load our luggage aboard.

I looked at the fragile little craft made of tarred canvas stretched over a wooden framework, and the back of my neck prickled in fright at the thought of four men and sundry baggage being borne in it over the choppy sea to Inislacken. However, my anxiety was as nothing compared to that of George who, when we had gingerly settled ourselves in the curragh, sat there rigidly upright, breathing rapidly, eyes screwed shut and hugging his guitar case for solace. It occurred to me to wonder if George could swim.

Gerard blithley ignored us and engaged Michael in lively conversation as between them they manned the oars, cross-handed in the island fashion, sending us skimming over the waves.

It was not long before my apprehension subsided and I found myself totally lost in the breathtaking grandeur of our surroundings. Behind us was Roundstone and the magnificient backdrop of the Twelve Bens mountain range, purple and gold in the evening light. We pitched and rolled in the all-encompassing ocean as gulls swooped round our heads and the oars rhythmically slapped in and out of the water. Ahead lay Inislacken – Island of the Lakes – a long grey and green sliver of rock, rising in humps to the centre and

Artist Basil Blackshaw, 1951

fringed with a soft beach of pearly sand.

When we at last made landfall it seemed to me to be an idyllic place of thatched cottages, some of them in ruins, set in treeless fields bounded by stone walls and all bathed in an almost mystical silvery light from the ever changing dome of the sky. A short walk up a slope from the landing place stood the cottage surrounded by a low stone wall inset with a wooden gate within which a riot of wild flowers and grasses vied for space. It had a slate roof, a blue painted door and window frames to match. Under one of the windows was a dilapidated wooden bench also painted blue and once I had dumped my possessions inside, I came out again and sat down on it.

I got out my pipe and took in the glorious landscape of Connemara which on one side stretched away to the horizon while on the other there was nothing to be seen but the wide ocean pounding its way to the coast of North

America. It mattered little where I gazed for inside my head paintings juggled for space as the subtle combinations of colours fused. Rarely, I thought, did one discover such a treasure trove of landscape. I was overwhelmed by the silence and serenity of this tiny island and heaved a sigh of pure bliss as I contemplated the coming weeks. It was a painter's paradise and I knew instinctively that the decision to come here would be one that I would never regret.

Lost in my dreams I suddenly caught sight of a shiny black beetle scurrying across a huge boulder in the corner of the garden. Then, almost simultaneously, a moth rose from among the wild flowers and lurched crazily into the still evening air. Given the multitude of long crevices and tiny cracks in the surrounding stone walls, I suspected an army of creepy-crawlies lurked there and suddenly my head was filled with memories of Hookey, whose blond eyebrows would have jumped with excitement at the idea. Many a time I had wondered what had become of our crawly book of which we had both been so proud. I had had no contact with Hookey since our schooldays and had been shocked to hear, years later, that he had been hurt in the bombing of Belfast on Easter Tuesday 1941 and had subsequently died of his injuries. However, I had never been able to confirm this.

Sitting listening to Gerard and George arguing and rummaging around in the cottage behind me, it came to me that my meeting with the Campbell brothers and their friends had been a watershed in my career. I had watched them, listened and acted on their advice, if it was relevant, when otherwise I might have struggled on in isolation for years. I knew the future might be fraught with difficulties and hardship and that I would probably never be rich but I also knew that I could never give up. So far I had been able to make just enough money to keep going and had been lucky to have had some favourable critical reviews. These critiques were read by my parents who seemed quietly pleased at my modest success but naturally, being ma and da, they would never have dreamed of mentioning it.

I sat watching the ebb and flow of the tidewater as it sloshed around the little harbour and thought that just a few weeks ago I could never have imagined myself sitting on a tiny island, on the edge of the Atlantic, with the prospect of weeks of painting and congenial company before me. A smile floated across my face at the thought of John Magee and his seventeen pounds.

My reverie was soon interrupted by a movement behind me and I turned to see Gerard, duncher pushed to the back of his head, standing in the doorway watching me, wearing one of his quizzical expressions.

'Come on,' he said, 'move yourself. You'll have plenty of time to paint and take in the scenery.'

With a sigh of contentment I got up and followed him into the cottage.

Mike
1952

Mike, 1951

EPILOGUE

One evening, a few weeks before Gerard's unexpected invitation to Inislacken, I walked into Shankill Branch Library and dumped my books on the high counter behind which a member of staff was rummaging, head down in a cupboard. She stood up and I was confronted by a pair of brown eyes set in a dark rosy complexion and surrounded by a mop of mid-brown hair. I fancied her immediately and thereafter my visits to the library became an almost daily occurrence. However, apart from the usual exchange of pleasantries she seemed hardly to be aware of my existence. She was quite a bit younger than I was and it seemed to me that if she gave me a thought at all it was probably only as a library user.

After my return from Inishlacken I hot-footed it down to the library, determined to ask her out. She didn't seem to have even noticed my absence so I waited a few more days and then I asked her if she would like to sit for a portrait. This got a reaction but not the one I wanted and I thought she was going to run a mile. Eventually I wore her down and got her to come to the cinema with me and later, she did sit for a portrait.

Her name was Mike and four years later in 1955 we were married.

ACKNOWLEDGEMENTS

This is a story based on memories. However, fifty-odd years is a long time and many of the people who might have jogged my recollections are sadly long gone. I apologise to the dwindling number of my old friends if I have left out anything they might deem to be important. I hope that the book will remind them of the times, good and bad, that we shared.

I would like to thank all those collectors who loaned my early paintings and drawings for the purposes of reproduction. I am also indebted to the people who provided photographs from their family albums and most especially to Margaret Campbell for permission to use Arthur's early photographs. I also appreciate the patience and help given to me by Esler Crawford and his staff and thank them for their quality negatives and prints. Finally there is Mike, my long-suffering wife, who nursed the book through its many difficulties. I thank her for her help and perseverance.